EAST LAKE
GOLF CLUB

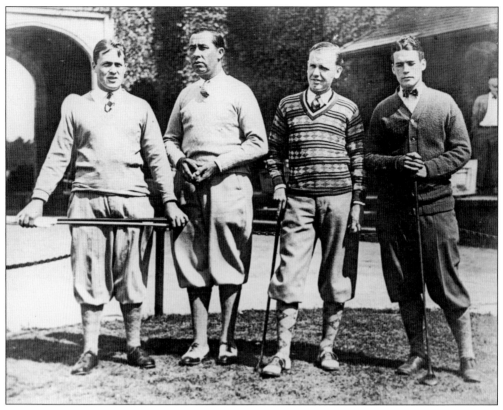

East Lake's Bobby Jones and Watts Gunn took on Walter Hagen and Harold Callaway in an exhibition match at East Lake in May 1925. Jones and Gunn bested their opponents. Pictured from left to right are Jones, Hagen, Callaway, and Gunn. (Courtesy Emory Manuscript, Archives, and Rare Book Library [MARBL]/Sidney Matthew Collection.)

FRONT COVER: Legendary golfer Bobby Jones learned how to play golf at East Lake Golf Club when the game was in its infancy. His natural ability earned him the reputation of being arguably the best amateur ever to play the game. (Sidney Matthew.)

BACK COVER: The 1920s and 1930s were truly the golden days of golf. The sport was rapidly gaining popularity, and some of the top young golfers in the world called East Lake Country Club their home. Watts Gunn (left), visiting Georgia golfer Walter Meacham (second from left), is pictured with Bobby Jones (second from right) and Charlie Yates. (Emory MARBL/Sidney Matthew Collection.)

COVER BACKGROUND: The No. 6 island green, shown here in the 1927 Southern Open, is the oldest island green in the United States. Bobby Jones won the Southern that year. (Sidney Matthew.)

EAST LAKE
GOLF CLUB

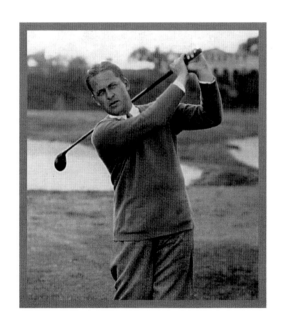

Sidney Matthew and Janice McDonald

ARCADIA
PUBLISHING

We dedicate this book to Tom Cousins, without whose commitment and determination there would no longer be an East Lake.

Published by Arcadia Publishing
Charleston, South Carolina

Printed in the United States of America

Library of Congress Control Number: 2015934794

For all general information, please contact Arcadia Publishing:
Telephone 843-853-2070
Fax 843-853-0044
E-mail sales@arcadiapublishing.com
For customer service and orders:
Toll-Free 1-888-313-2665

Visit us on the Internet at www.arcadiapublishing.com

CONTENTS

ACKNOWLEDGMENTS

When you mention "East Lake" to golf lovers and longtime Atlanta residents, you immediately get a smile and a story. The club's rich history lends itself to so many memories that when we undertook this project, countless people offered their assistance. Even people not directly connected to the club knew someone associated with it. It of course helps that one of us (Sidney Matthew) has been a part of East Lake's history and has been instrumental in preserving its heritage. We would like to thank the following people for their assistance and encouragement throughout this process: the Atlanta Athletic Club; the Atlanta History Center; the *Atlanta Journal-Constitution*; Chris Borders, former Atlanta Athletic Club general manager; Rick Burton, East Lake chief executive officer; Tom and Ann Cousins; the East Lake Golf Club; the Florida State Archives; the Georgia State Archives; the Hagley Museum and Library; Lillian Giornelli, the East Lake Foundation: Leon Gilmore, the First Tee Program; Randy Gue, curator of the Bobby Jones Exhibit at Emory's Manuscript, Archives, and Rare Book Library (MARBL); Liz Gurley, our fabulous editor at Arcadia Publishing; David and Leslye Hardie; Donald Hardie; Charlie and Sylvia Harrison; John Imlay, the Friends of Bobby Jones; Sara Logue, Emory/MARBL; the State Bar of Georgia; Linda Matthew; Stacy Meschke; Bill O'Callaghan, the Atlanta Athletic Club; Duane Stork; Steve Watkins; Kelley Wiedenmann, East Lake; and Jennie Toale.

INTRODUCTION

When Robert Alston first turned a boggy section of his 400-acre property into a glistening 30-acre lake, he could have never dreamed that East Lake would become the center of what is considered one of golf's most historic courses. It was the mid-1800s, and the property was six miles east of the growing Georgia capital of Atlanta. Alston, an attorney, wanted to create a haven for his new bride.

Over the years, the lake would draw many to its shores. During the Civil War, soldiers camped there. A few decades later, it became a destination for Atlantans wanting to escape the city to enjoy a host of recreational activities.

Colonel Alston farmed his property for 25 years, using the lake as a fishpond. While serving in the state legislature, he became vocal in his opposition to the state's practice of leasing convicts to businesses to be used as labor. Alston received death threats over his stance and was shot and killed inside the capital building in 1879 by a political opponent. His property was eventually sold in 1891 to the newly formed East Lake Land Company. The plan was to sell lots for summer cottages. Developers built a dance hall and created a beach on the lake, offering opportunities for potential residents to enjoy lawn bowling, tennis, fishing, and boating. The land company even succeeded in connecting a streetcar line to the property from downtown Atlanta to make it easy for people to visit.

The cottages were popular, but a recession hit and the land company failed. Later, Thomas Poole operated a small amusement park at the lake, taking advantage of the facilities built by the land company. The park also included a penny arcade where the curious could peep at images of the 1889 Paris World's Fair and even Pike's Peak. A small steam launch, *Gladys*, took passengers around the lake.

Around this time, social clubs were becoming the popular way for Atlanta high society to interact. Attorney Burton Smith wanted to take the social mingling a step further to include athletics. In 1898, he and some friends chartered the Atlanta Athletic Club (AAC), which included a variety of athletic activities. They formed teams for basketball, baseball, boxing, shooting, and tennis. Within a few years, the AAC had grown from 26 members to more than 700.

Georgia Power Company founder Harry Atkinson obtained options on the 187-acre East Lake property to create a golf course, forming the Country Club Association. The relatively new sport was rapidly gaining popularity, and AAC president George W. Adair was enamored with the idea of his club having its own golf course. In 1904, Atkinson gave the AAC his option to create the AAC's East Lake Country Club.

A year later, Scottish-born golf architect Tom Bendelow arrived in Atlanta to design the club's course. Known as the "Johnny Appleseed of American golf," Bendelow designed more than 600 courses in his lifetime. While he designed the nine-hole course, it was up to Fred Pickering to actually build it.

As the two-year construction project got under way, the AAC hired its first golf pro. Alex Smith hailed from Carnoustie, Scotland, and had made his name winning golf titles, including the Western Open twice as well as the US Open, before he came to East Lake in 1906. Smith only stayed a year, and the AAC was already on its second golf pro before the course opened. Jimmy Maiden, also from Carnoustie, replaced Smith in 1907.

Among those attending the grand opening of the AAC's East Lake Golf Course on July 4, 1908, was a six-year-old named Bobby Jones. His father was a club member, and Bobby became fascinated with golf.

Jimmy Maiden's brother Stewart worked at East Lake, and young Jones would tag along, following him on the course and copying his every move. Maiden showed patience with other children in the neighborhood as well, including Alexa Stirling and Perry Adair. Those two also became champion golfers.

While Bobby Jones went on to become the most celebrated amateur golfer in US history, it was Alexa who became East Lake's first champion, capturing the women's US Amateur three times in a row, beginning in 1916. The "First Lady of East Lake" won numerous championships and maintained a lifelong friendship with Jones.

Bobby Jones was a child prodigy. He was just nine years old when he won the Junior Club championship at East Lake in 1911 and only 14 when he made it to the quarterfinals of the US Amateur tournament. His first regional title came in 1917, when he won the Southern Amateur, a title he would claim again in 1920 and 1922. From 1922 to 1930, he captured 13 major titles.

About the same time Jones was making his mark on world golf, East Lake was expanding. Famed course architect Donald Ross expanded the original nine holes to 18 in 1913 and designed a second course in 1928. On May 31, 1930, the day No. 2 opened, Jones won the British Amateur. That year, he did the impossible, winning the US Amateur, the US Open, the British Amateur, and the British Open—the Grand Slam.

Over a span of 30 years, Bobby Jones, Alexa Stirling, and Charlie Yates won 17 major championships, more than any other American club. They became known as the "Champions of East Lake," a moniker that remains intact today.

Having these players as members did much to propel East Lake's already growing status as one of the world's premier golf courses. Numerous tournaments were held there, including the Southern Amateur, the Southern Open, the Women's US Amateur in 1950, and the 1963 Ryder Cup.

While East Lake was being celebrated, its neighborhood was not. Urban decay set in, and the Atlanta Athletic Club opted to sell the No. 2 course, moving north of Atlanta to Jones Creek. A public housing project, East Lake Meadows, was built on No. 2's land, and the No.1 course began a sad downward spiral.

In 1993, developer Tom Cousins stepped in to preserve East Lake and its championship legacy, hoping to restore East Lake to its previous spender. The motto for the revitalized East Lake Golf Club was "Golf with a Purpose." Noted golf architect Rees Jones, working with Donald Ross's original golf course routing, helped restore the original course in 1994. Using the original Neel Reid architectural drawings, the clubhouse was brought back to its 1926 design.

All of these changes helped attract corporate members and garnered the attention of the PGA Tour. In 1998, championship tournament golf returned to East Lake with the PGA Tour's Tour Championship.

Tom Cousins and others did not stop with just revitalizing the club—they transformed the entire community through the East Lake Foundation. The foundation created affordable housing, schools, community programs, and even the Charlie Yates Golf Course, where neighborhood youth can learn the game of golf. "Golf with a Purpose" is today at the heart of creating Purpose Built Communities, a program that shows communities across the United States how to make similar transformations. East Lake is once again a golf community to be revered.

BEFORE THE COURSE

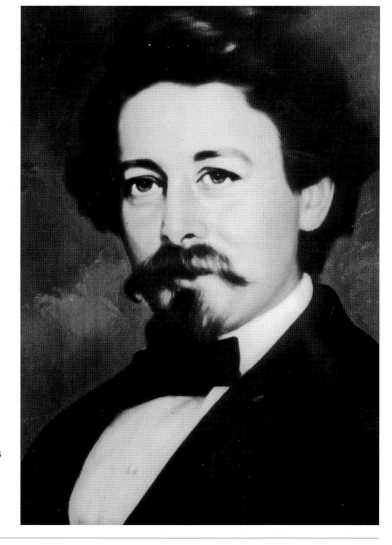

In 1854, attorney Robert Alston initially bought 300 acres of land along Fayetteville Road to build a home for his future bride. Located five miles east of Atlanta, the area was considered remote wilderness. The antebellum mansion was called Meadow Nook. Today, it stands across Alston Drive from the No. 3 fairway of East Lake Golf Club. (Charles Harrison.)

Alston met his wife, Mary Charlotte Magill Alston, while he was living in Charleston, South Carolina. He designed Meadow Nook to reflect the type of homes of her native Lowcountry region. It features wraparound porches, Doric columns, and six fireplaces adorned with Italian and Austrian marble. It took five years to design and build Meadow Nook. Construction was overseen by local carpenter Andrew Marshall. (Charles Harrison.)

While Meadow Nook was under construction, Alston decided to make use of a stream at the foot of his backyard. The stream fed what he referred to as a "bog," making the land useless for farming. He excavated the low-lying area and created a pond, stocking it with fish and creating a fish farm. It was first called Alston Pond but is now known as East Lake. (Emory MARBL/ Sidney Matthew Collection.)

BEFORE THE COURSE

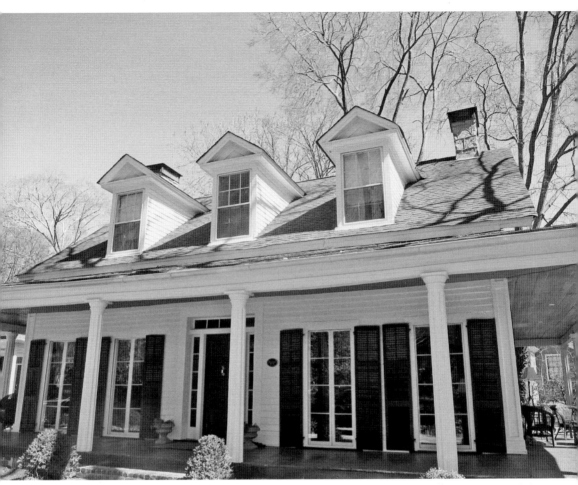

Meadow Nook's remote location was a haven for the Alstons and their children. It also provided them a great retreat to host guests both before and after the Civil War. Alston was often described as being gallant. A Charleston newspaper wrote of Alston in his obituary that he was known for his "Southern welcome" and "the warm grasp of his friendly hand." It reflected after his death, "His many friends will remember with pleasure the gentlemanly hospitality which he dispensed to them." Meadow Nook was purchased in 1994 by East Lake champion golfer Charlie Harrison's wife, Sylvia. The Harrisons painstakingly restored it, and Meadow Nook is now listed in the National Register of Historic Places. (Janice McDonald.)

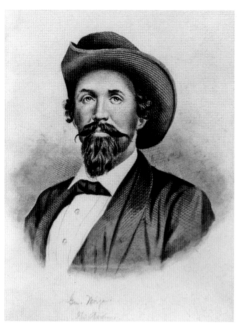

When the Civil War erupted in 1861, Alston sided with the South, joining Brig. Gen. John Hunt Morgan's cavalry in a unit that became known as Morgan's Raiders. Alston was eventually elevated to the rank of colonel. In January 1863, Southern forces used Alston's property for encampments. The soldiers staked their tents in the area of what is now East Lake Golf Club. Morgan is pictured here. (Library of Congress.)

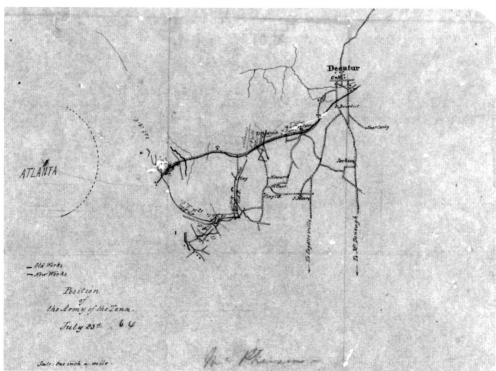

This map signed by Union general James McPherson shows the Confederate positions west of downtown Decatur in 1864. McPherson commanded the XVII Corps in the Army of the Tennessee. The Alston Plantation was located just to the north of where "Fayette Rd" is written on the map. The road splitting off to the west is now Glenwood Avenue. In 2008, a Civil War–era cannonball was found during work near the No. 4 fairway. (Library of Congress.)

BEFORE THE COURSE

On July 22, 1864, the day of the Battle of Atlanta, Confederate general William Henry Talbot Walker (above left) was scouting Union lines one mile west of what is now the No. 5 tee of East Lake Golf Club when he was shot from his horse and killed. Within a few hours, Union general James McPherson (above center) was killed after encountering Confederate soldiers a mile away at what is now Monument Avenue. Soon after the battle, Union general John Schofield (above right) took over the Alston home as his headquarters. A few miles away, Gen. William Tecumseh Sherman occupied a mansion owned by Samuel House, which now serves as the Peachtree Golf Club clubhouse. (Above left, Janice McDonald; above center and above right, Library of Congress.)

Following the war, Robert Alston joined forces with Henry Grady and Alexander St. Clair Abrams to found the *Atlanta Herald* newspaper, which was the predecessor of today's *Atlanta Journal-Constitution*. Alston threw himself into the politics of Reconstruction, becoming one of the leading voices of the Georgia Democratic Party. He was also elected DeKalb County's state representative. (Digital Library of Georgia.)

As chairman of Georgia's penitentiary committee, Alston exposed deplorable conditions under which prisoners were being leased out to build railroads or work mines and farms. Many of the convicts were former slaves who had been jailed on trumped-up charges. He received numerous death threats for his stance against the practice. On March 11, 1879, Alston was gunned down by political opponent Ed Cox while at the Georgia State Capitol. (Atlanta History Center.)

In 1891, a large portion of the former Alston property was acquired by the newly chartered East Lake Land Company. This short article from the *Sunny South* newspaper from November 21, 1891, is one of the many small articles planted in local newspapers to entice potential buyers to the new development. The company envisioned a summer resort where residents could escape the hustle of the city. (Georgia State Archives.)

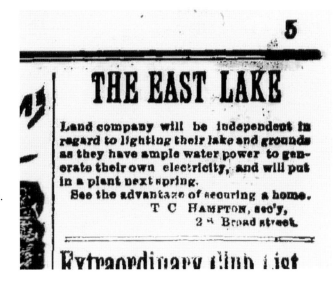

5

THE EAST LAKE

Land company will be independent in regard to lighting their lake and grounds as they have ample water power to generate their own electricity, and will put in a plant next spring.

See the advantage of securing a home.
T C HAMPTON, sec'y,
2 ½ Broad street.

Extraordinary Club List

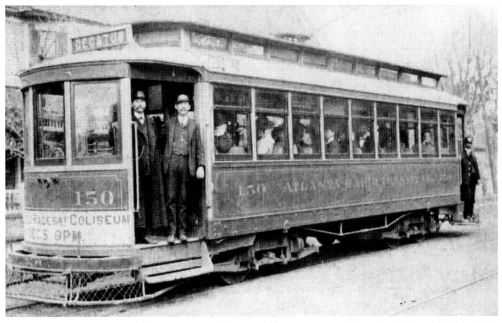

To attract more potential buyers, East Lake Land Company president A.C. Bruce lobbied the Atlanta City Street Railway Company to run a streetcar line to the property. By 1893, there was service every 20 minutes from Atlanta via Decatur. Cars followed what is now East Lake Drive, intersecting with an older line at present-day Oakview Road. That crossroads contributed to the development of the Oakhurst neighborhood. (Sidney Matthew.)

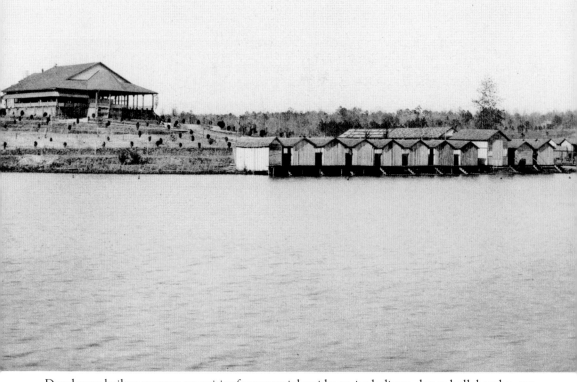

Developers built numerous amenities for potential residents, including a dance hall, boathouses, a beach, tennis courts, and a lawn bowling court. East Lake's resort proved popular, but an economic panic hit in 1893, and the venture failed. Thomas Poole took over the lakefront property, operating a small amusement park that he compared to New York's Coney Island. He utilized the facilities built by the land company but also added games and sideshows, complete with an organ grinder and his monkey. A penny arcade allowed the curious to peep at images of the 1889 Paris World's Fair and even Pike's Peak. A small steam launch, *Gladys*, took passengers around the lake. (Atlanta History Center.)

BEFORE THE COURSE

At the turn of the 20th century, local newspapers and magazines kept track of "picnic parties" that took place on a regular basis. East Lake was among the most popular destinations even though Poole's amusement park was no longer in operation. At one point, the mayor of Atlanta considered making East Lake an Atlanta city park, but city council deemed it too far outside of the city. (Emory MARBL/Sidney Matthew Collection.)

Atlanta was becoming a boomtown, and social clubs were growing in popularity. Jewish Atlantans formed the Concordia Association (later the Standard Club) in 1867, and in 1883, the Nine O'clock German Club was founded. The Capital City Club, pictured here, began in 1883 and was located in the home of Josephine A. Richards on Peachtree Street near Ellis Street. The Gentleman's Driving Association (Piedmont Driving Club) began in 1887. (Atlanta History Center.)

A recent transplant to Atlanta, attorney Burton Smith conceived a club that would combine social activities with athletics. Within weeks of Smith presenting his idea to friends and business associates, 64 people had voiced their support. On September 6, 1898, sixty-five members signed a charter creating the Atlanta Athletic Club. The initiation fee was $25, and annuals dues were $24. Smith became the AAC's first president. (State Bar of Georgia.)

The AAC's first clubhouse was located below the Equitable Building on Edgewood Avenue. Charter member Joel Hurt owned the building and arranged a five-year lease. Within three years, AAC membership had swelled to 700, outgrowing its facilities. The AAC bought property one block over, at 37 Auburn Avenue, and designed a building around the club's growing needs. The doors opened on November 27, 1902. (Georgia Department of Natural Resources.)

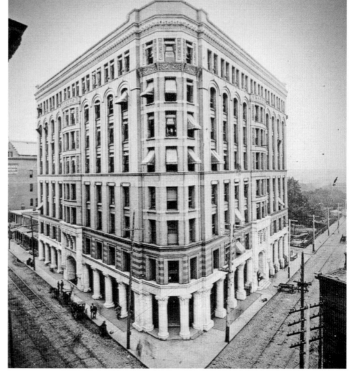

BEFORE THE COURSE

Georgia Electric Light Company founder Henry "Harry" Atkinson was interested in the East Lake property. A banker and entrepreneur, Atkinson had been involved in railroads and streetcar companies before forming what would one day become the Georgia Power Company. In 1904, Atkinson chartered the Country Club Association. He obtained a purchase option for 177 acres around the lake on which to build a golf course. Atkinson envisioned transforming East Lake into the "St. Andrews of America." One of the initial investors was his Harvard classmate Thomas Jefferson Coolidge, grandson of Pres. Thomas Jefferson. Pictured at right is Atkinson's official Georgia Power portrait, and below, he is shown with his grandsons. (Both, Georgia Power Company.)

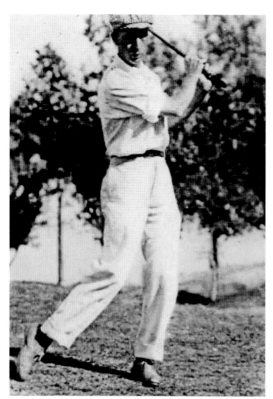

With golf's growing popularity, the AAC's second president, George Washington Adair, felt the club should have its own course. He was intrigued when he first heard about Atkinson's plan to build a golf course at East Lake and was vocal about his desire to have the land for his club. A member of the AAC himself, Atkinson graciously offered to give his East Lake golf course property option to the athletic club. (Sidney Matthew.)

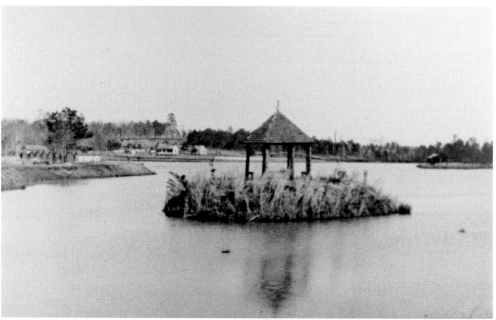

On September 26, 1905, the *Atlanta Constitution* reported that the AAC membership had unanimously voted to support a lease purchase agreement. The article touted the 38-acre lake as the "finest body of water in the vicinity of Atlanta." Adair became known as the "Father of Golf in Atlanta." (Sidney Matthew.)

THE ATLANTA ATHLETIC CLUB AT EAST LAKE

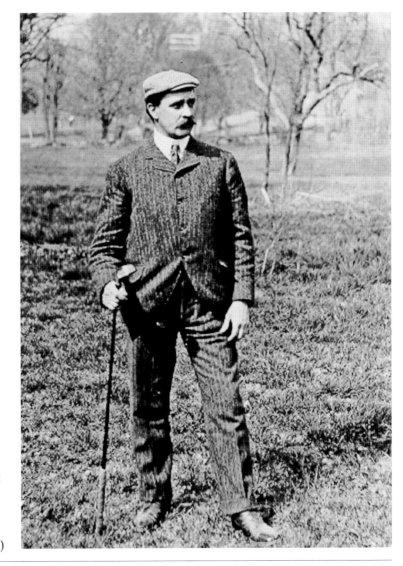

The Atlanta Athletic Club contracted noted golf club architect Tom Bendelow from Aberdeen, Scotland, to design the East Lake course. He arrived in Atlanta on October 5, 1905. A prolific designer, Bendelow was called the "Johnny Appleseed of American Golf Courses," designing more than 600 courses in 35 years. (Michigan State University Libraries.)

While Tom Bendelow (pictured) drew and laid out the course, the task of actually building it fell on Fred Pickering. The two functioned as a team on numerous courses across the United States. Bendelow would design it and move on, while Pickering stayed behind to build it. In the case of East Lake, Pickering stayed long enough to function as master of ceremonies when the course opened in July 1906. (Sidney Matthew.)

The *Atlanta Constitution* declared, "This course is a thing of beauty and joy forever and every hill and ravine tells a victory to be won." Pickering predicted, "All you need to do is just to give one tournament and get the cracks of the country to come here and look at the course and then await the developments." This photograph looks east along Morgan Street (now Alston Drive). (Sidney Matthew.)

The cost of building the course was $15,000. Six houses that had been built as part of the East Lake development had to be torn down and removed. The original property was heavily forested with rolling hills, so ditches and ravines had to be filled in to make way for fairways and greens. Most of the work to grade and shape the terrain was done by hand with axes, picks, and shovels. While the original plans allowed for 18 holes, the course was built in phases. The first phase initially called for just seven holes. Once work began, the number of holes was expanded to nine. The layout featured three hazards over the lake and numerous artificial hazards along the course itself. (Both, Sidney Matthew.)

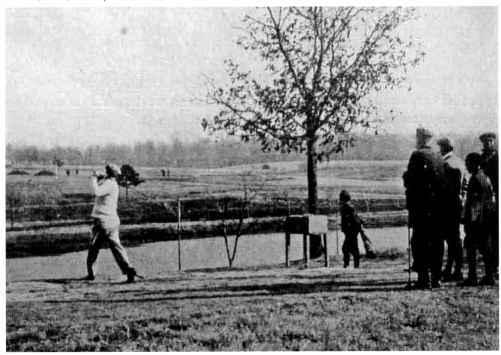

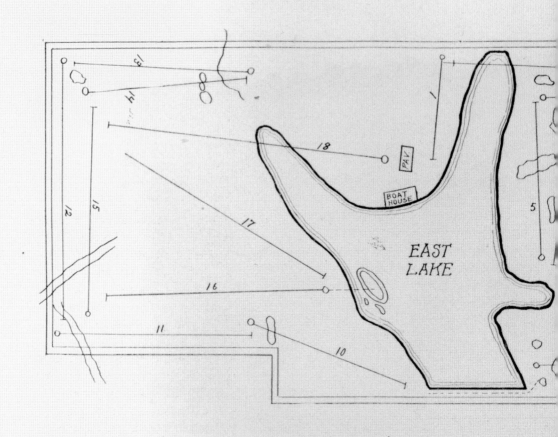

THE GOLF COURSE
Showing the 18 Holes, Distances and Bo

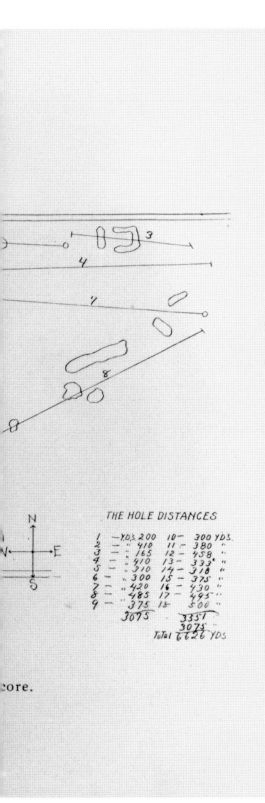

THE HOLE DISTANCES

1	—YDS. 200	10—	300 YDS.
2	— " 410	11 —	380 "
3	— : 165	12 —	458 "
4	— . 410	13 —	333 "
5	— . 310	14 —	310 "
6	— . 300	15 —	375 "
7	— .. 420	16 —	430 "
8	— .. 485	17 —	495 "
9	— 375	18 —	500 "
	3075		3351
			3075
		ToTal	6626 YDS

:ore.

This map depicts Bendelow's original layout for the East Lake course. The No. 1 tee was located on a knoll where today's clubhouse now stands. That first hole ran from the side of the clubhouse (across the lake from the current No. 17 green) to what is now the No. 10 tee. The course played clockwise, which is completely opposite of today's layout. The first nine holes were to the east of the lake, while the last nine were to the west. People wanting to play only nine would find themselves across the lake from the clubhouse. The No. 9 green was located across the lake from the clubhouse, where today's No. 16 green is located. To play No. 10, golfers walked across the dam that created the lake. The 6,626-yard course had just two par-3 holes (No. 1 and No. 3); the rest of the layout was composed of short par-4s, par-4 1/2s, and par-5s. (Emory MARBL/Sidney Matthew Collection.)

The Atlanta Athletic Club retained golfer Alex Smith to become the club's first golf professional in early 1906, even though the course was not yet open. Smith immigrated to the United States from Carnoustie, Scotland, in 1898 along with his five brothers. Brother Willie won the US Open in 1899. When Alex arrived at East Lake, he had already won the Western Open in 1903 and 1906, as well as the 1906 US Open. He won the US Open again in 1910. In all, Smith played in 18 US Opens and accumulated 11 top-10 finishes. The trading card below is part of a series published in 1910 by the American Tobacco Company depicting well-known American golfers. (Both, Sidney Matthew.)

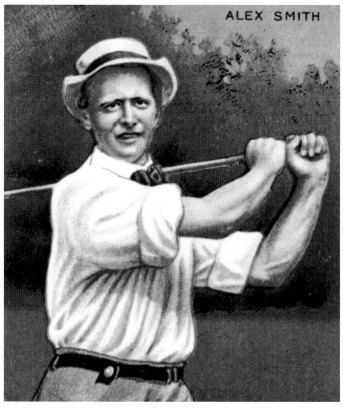

ALEX SMITH

With construction of the course under way, work began on facilities for club members. A new boathouse and bathhouse were constructed right at the water's edge. Club president George Adair promised 10 tennis courts: seven were clay and three turf. A gun club range was added on the north side of Morgan Street for shooting enthusiasts. Long-term plans included a park that could be used for baseball, football, and track. (Atlanta History Center.)

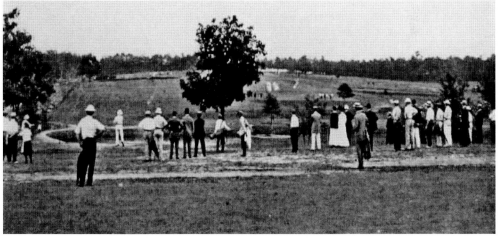

The golf course opened amid much fanfare on July 4, 1906. Among those in attendance were Col. Robert P. Jones and his five-year-old son Bob. The next year, the course was extended to 17 holes and thereafter 18 holes. In 1907, East Lake hosted its first major tournament, the Southern Amateur; Nelson Whitney was the winner. This photograph is from the 1910 Southern Championship Meet. (Sidney Matthew.)

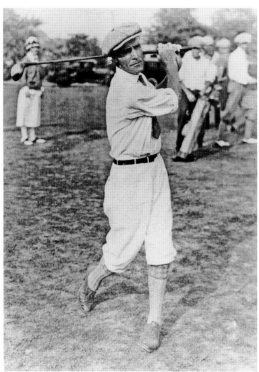

In 1907, noted Scottish golfer James "Jimmy" Maiden became the Atlanta Athletic Club's second golf pro. Part of the reason he came to the club's attention was that he was Alex Smith's brother-in-law. The Carnoustie native's tenure with East Lake was for one year, starting on March 1, 1907. He was offered the handsome salary of $60 a month, payable at the end of each month. (East Lake Golf Club.)

Jimmy Maiden's duties included overseeing East Lake's master caddy as well as the caddies themselves. According to his agreement, he could charge no more than $1 for 45 minutes of golf lessons. He was also allowed to make, repair, and sell golf clubs. The club required that he be on site between 9:00 a.m. and 6:00 p.m. daily. This is the original East Lake Caddy House. (Sidney Matthew.)

Jimmy Maiden hired his younger brother Stewart as his assistant. The colorful Scot was known for his wit and skill, quickly becoming a favorite among the membership. When Jimmy decided to leave East Lake to return to Nassau Country Club in New York, Stewart was the popular choice to replace him as East Lake's pro. (Sidney Matthew.)

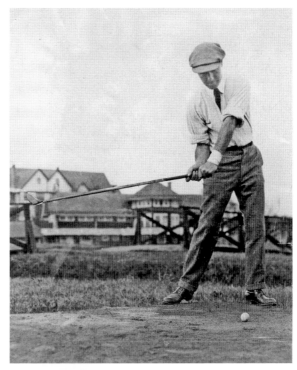

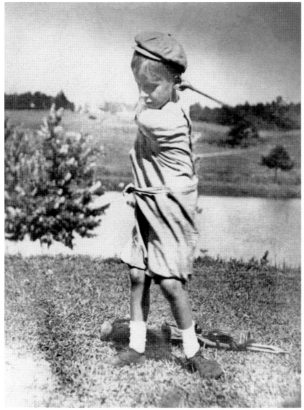

Stewart Maiden's greatest contribution to golf was allowing a young kid from the neighborhood to follow him around the course. Six-year-old Bobby Jones lived across the street from East Lake and became enamored with the sport. He tagged along with Maiden as he played, mimicking the upright swing that Stewart had perfected on his home course, the Carnoustie Golf Club of Scotland. (Sidney Matthew.)

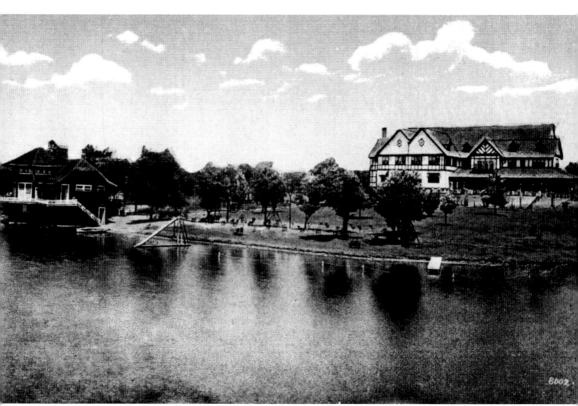

Architect Harry Leslie Walker was hired by the AAC on April 13, 1907, to build a clubhouse at East Lake for the proposed cost of $45,000. Donations for the clubhouse were considered voluntary, but the *Atlanta Constitution* reported that money was "rolling in" from wealthy members. Harry Atkinson led the way with $5,000; George Adair gave $1,000. The pavilion built for the original East Lake Land Company was removed to make way for the new structure. The forward-thinking Adair had previously negotiated phone service to the property at a cost of $3 a month. The first East Lake County Club clubhouse opened on July 4, 1908. At the time, it had no kitchen facilities, so on July 1, 1908, the AAC signed a deal with the Silverman Catering Company to provide food from July 1 to October 1. (Sidney Matthew.)

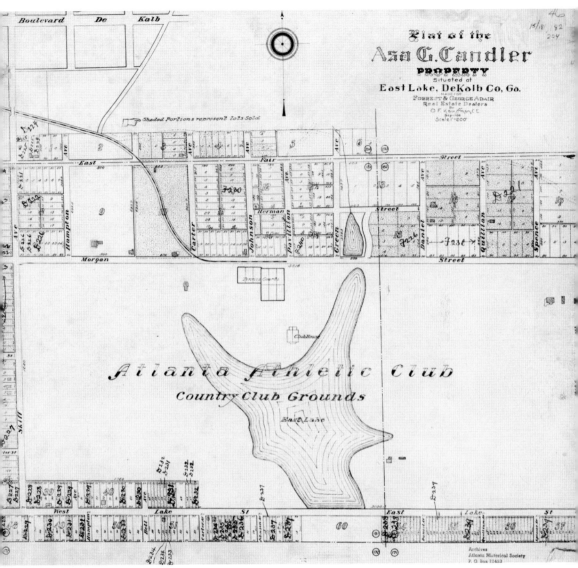

Atlanta businessman Asa Candler began using agents to secretly buy up the land around the country club. Candler was already enjoying success in marketing and selling a new fountain drink called Coca-Cola. He had purchased the drink recipe 10 years earlier from local pharmacist John Stith Pemberton and started the Coca-Cola Company. Candler's diverse interests included banks and real estate development. This map shows how the East Lake neighborhood was growing. In December 1907, Harry Atkinson's Georgia Electric and Railway Company added first-class streetcar service to East Lake. The line ran behind the old Alston home, ending at the tennis courts on Morgan Drive (now Alston Drive). The *Atlanta Georgian* newspaper declared, "With the new car service, the new club house, the best golf course and the best tennis courts in the South, the East Lake Club is going to be the greatest the South has ever known and a success beyond even the expectations of its founders." (Atlanta Athletic Club.)

The first club championship for East Lake was held in 1907. It was won by F.G. Byrd, who lived across from the No. 3 fairway in the former Robert Alston house. Byrd won the championship again in 1908 and 1910. Byrd also won the Southern Amateur in 1910. The Atlanta native played in regional tournaments and later designed the Rocky Point Golf Course in Tampa, Florida. (Sidney Matthew.)

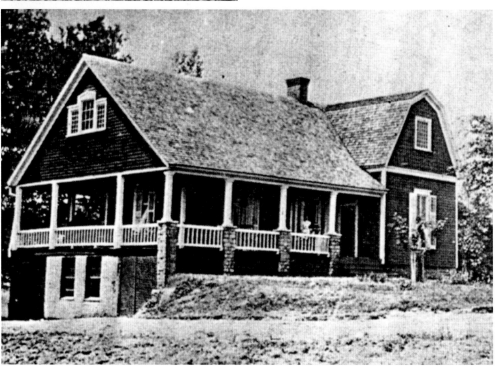

Horse-drawn mowers kept the course in shape. The equipment was housed in the "Mule House," located west of the tennis courts near the present No. 2 green. The house was later renovated and rented by Bobby Jones's parents as a summer home. The livery stables were situated across Alston Road on the Bachman Farm until the 1950s, when it was donated to the City of Atlanta. It is now East Lake Park. (Sidney Matthew.)

THE ATLANTA ATHLETIC CLUB AT EAST LAKE

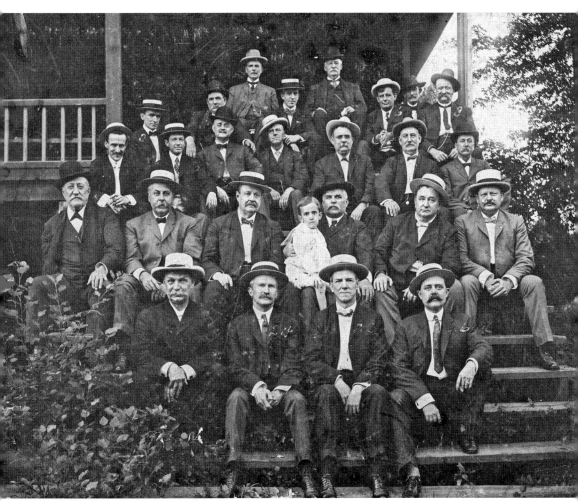

This photograph of the Homosassa Fishing Club was taken on the steps of the first East Lake clubhouse during a fish fry given by Nym Hurt. The club was originally founded in 1899 by Atlanta business leaders who made an annual pilgrimage to Homosassa Springs, Florida, 425 miles away. The members seen here in 1910 are, from left to right, (first row) Anton Kontz, E.C. Peters, D.B. Desaussure, and Clarke Howell; (second row) John Berkele, Dave Woodward, C.E. Currier, Toulman Hurt, James Lawrence Harrison, and Howard Van Epps; (third row) T.T. Williams, George Muse, Henry Durand, Frank Rice, J.C.A. Brannen, I.S. Mitchell, and W.S. Duncan; (fourth row) W.B. Stovall, T.M. Armstead, Preston Arkwright, H.Y. McCord, Nym Hurt, and Dave Wyley; (fifth row) George S. Lowndes and A.W. Calhoun. (Charles Harrison.)

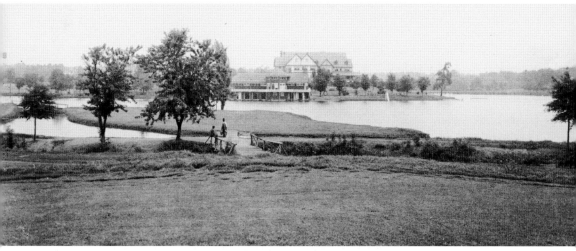

Fire claimed the first clubhouse, burning it to the ground in 1912. By then, the membership was almost 1,000. The new clubhouse was substantially larger and was designed by Hal Hentz and Neel Reid of the architectural firm Hentz and Reid. It featured modern conveniences such as complete plumbing, electrical systems, and phone systems. To pay for the larger, more improved facilities, the club issued 25-year, six-percent gold bonds. In the meantime, the East Lake neighborhood was growing. The community was incorporated as the City of East Lake in 1908. Tom Paine became the first mayor. A year later, an auto road was constructed from Ponce de Leon Avenue in Decatur to the gates of the country club. By 1916, a school building had been erected on Fourth Avenue for $10,000. According to an *Atlanta Constitution* article in May 1916, demand for East Lake homes had reached boom proportions. (Sidney Matthew.)

THE ATLANTA ATHLETIC CLUB AT EAST LAKE

The course was completely renovated in 1913 with the guidance of golf architect Donald Ross. The original Bendelow course was played clockwise, but Ross reversed the route so that the front and back nine holes each ended at the clubhouse. Ross hailed from Dornoch, Scotland, and is credited with shaping today's US golf industry. Between 1910 and 1948, Ross designed or redesigned more than 400 courses. (Library of Congress.)

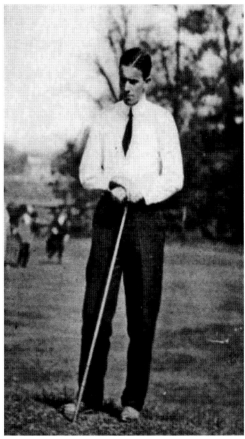

George Adair's reputation for creating the East Lake Country Club and its golf course earned him the nickname the "Father of Golf in Atlanta," and many consider him the "Father of Golf in the South." Adair traveled widely, playing in tournaments and advising other cities on how to form clubs and design golf courses. He won the title of Atlanta city golf champion in both 1914 and 1915. (Sidney Matthew.)

Young Alexa Stirling lived in a home directly opposite of what is now the No. 10 tee. Although she was more interested in the violin, her parents hired Stewart Maiden to teach her to golf. She was just 12 years old when she won her first tournament at East Lake. Her numerous wins in the United States, Britain, and Canada earned her the title the "First Lady of East Lake." (Sidney Matthew.)

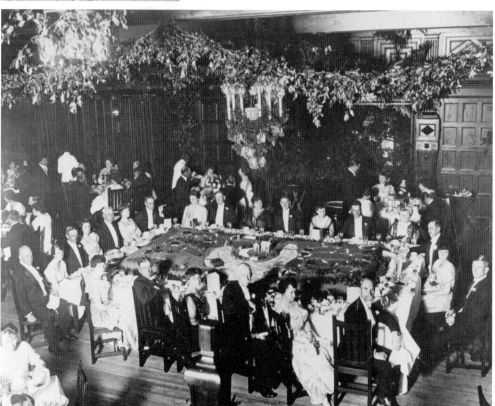

Stirling won her first US Amateur championship in 1916 at Belmont Springs Country Club in Massachusetts. She was East Lake's first official national championship winner. In celebration of the honor, a dinner party that included 305 guests was held at East Lake. The main table's centerpiece was a replica of the East Lake course. Stirling is at the head of the table on the far right. (East Lake Golf Club.)

George Adair's son Perry was among East Lake's young golf phenoms. Just two years older than Bobby Jones, the two often competed against one another. Adair won the 1914 East Lake Country Club championship and was the 1921 and 1923 Southern Amateur champion and the 1922 Georgia State Amateur champion. After his father died in 1922, Adair gave up golf entirely to help run the real estate business built by his father and uncle. (Sidney Matthew.)

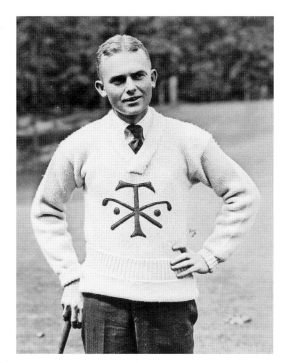

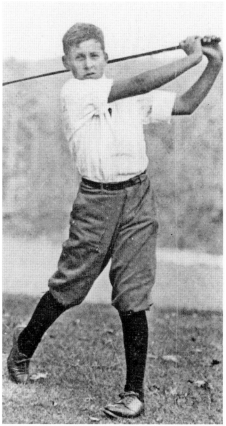

At 14 years of age, Bobby Jones competed in his first US Amateur, having already won the Georgia State Amateur. His distinction of being the youngest player to compete in the national tournament still stands. Athletic club president George Adair took Jones, as well as his son Perry, to Merion Cricket Club for the US Amateur competition. Jones lost in the third round to Robert A. Gardner. (Sidney Matthew.)

THE EAST LAKE GOLF CLUB

In February 1916, Stewart Maiden set a new course record at East Lake with a score of 31-32–63. His partner that day was 14-year-old "Little Bob Jones." Maiden had earned the nickname "Kiltie" as a small child in his native Scotland because he wore kilts. Later, when Alexa Stirling and Bobby Jones began winning championships, Maiden was dubbed "Kiltie the Kingmaker." (Sidney Matthew.)

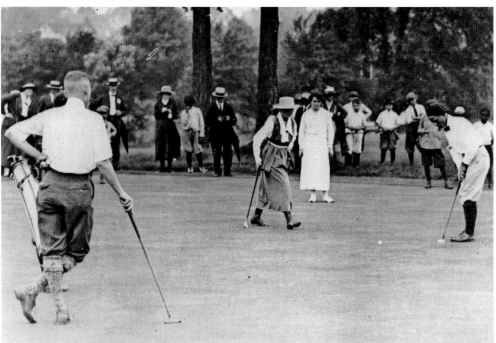

Stewart Maiden's three protégés, Alexa Stirling, Perry Adair, and Bobby Jones, joined forces near the end of World War I to raise money for the Red Cross. Known as the "Dixie Whiz Kids," they teamed up with three-time women's Western Amateur champion Elaine Rosenthal on exhibition tours around the country. At left, Adair is leaning on his club while Stirling is walking; Rosenthal watches while Jones putts. (Sidney Matthew.)

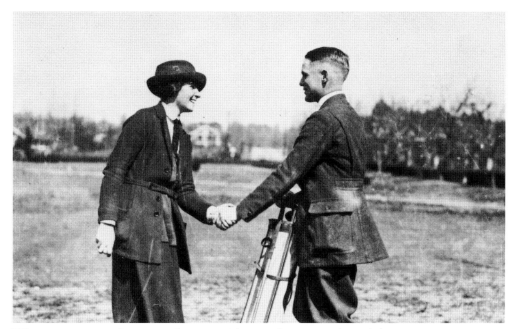

When tournament play resumed in 1920, Alexa Stirling again claimed the women's US Amateur championship after previously winning in 1916 and 1917. Her friend Bobby Jones was among the first to congratulate her on the victory. In all, Stirling won three majors and eight championships during her career. (Sidney Matthew.)

Stirling's national successes spurred more women in Atlanta to take up the sport of golf. In 1922, the Atlanta Women's Golf Association and the Georgia Women's Golf Association were founded for "the purpose of promoting interest in golf and inter-club competition among the women of the association's member clubs." Those clubs included Ansley Golf Club, AAC (East Lake), Capital City Club, and the Druid Hills Golf Club. (Sidney Matthew.)

THE EAST LAKE GOLF CLUB

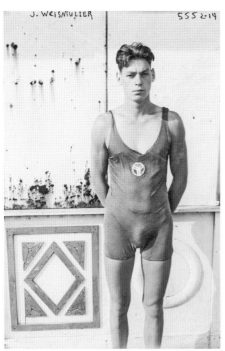

On September 9, 1922, the club hosted a national senior outdoor swimming event sanctioned by the Amateur Athletic Union (AAU). Among those competing was world-record holder Johnny Weissmuller. He competed in the 50 yard and 150 yard competitions, winning both. Two years later, Weissmuller won five gold medals at the 1924 Paris Summer Olympic Games. Many remember him best as a movie star who played *Tarzan*. (Library of Congress.)

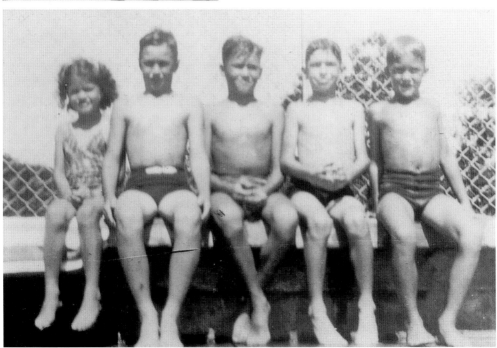

Atlanta developer Tom Cousins credits Weissmuller with having taught his mother how to swim. Cousins is shown here in the 1940s at East Lake with his siblings and cousins. From left to right are Louise Cousins, Jim Harrison Jr., Bill Cousins, Charles "Charlie" Harrison, and Tom Cousins. In the 1970s, Tom bought East Lake, saving it and its surrounding neighborhoods. Charlie would become a Georgia golf legend. (Charles Harrison.)

THE ATLANTA ATHLETIC CLUB AT EAST LAKE

Watts Gunn was born in Macon, Georgia, and played golf while a student at Georgia Tech. He joined the Atlanta Athletic Club, claiming the title of East Lake Club champion in 1925. He quickly earned the nickname "The Southern Hurricane." Gunn and Bobby Jones were friends as well as golf rivals, often playing as teammates as well as adversaries. (Sidney Matthew.)

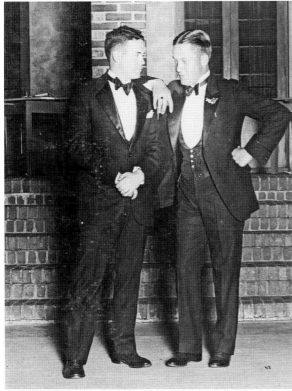

During the 1925 US Amateur, Gunn set the world record for international championship golf by winning 15 straight holes in the first round of a 36-hole match. He lost to Bobby Jones in the finals, marking the only time that two players from the same club ever met for the US Amateur crown. Both were on the 1926 and 1928 Walker Cup teams, defeating the British team each year. (Sidney Matthew.)

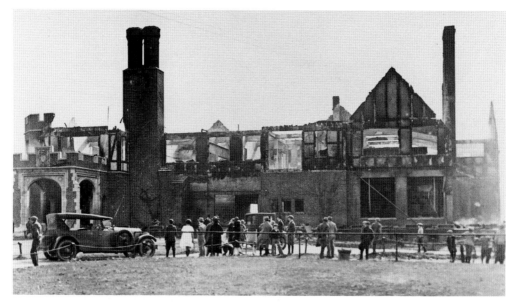

On November 22, 1925, fire gutted the second East Lake clubhouse. An investigation found that the blaze originated with faulty wiring in the first-floor lounge. Club superintendent W.C. Carpenter and his wife were severely injured trying to rescue the numerous trophies on display. The *Atlanta Constitution* reported that hundreds of silver and gold cups were "melted into unsightly lumps of metal." Bobby Jones lost several trophies, including the original Havemeyer Trophy. The trophy was donated in 1894 by Theodore A. Havemeyer, president of the newly formed United States Golf Association. It was loaned yearly to the US Amateur championship winner. In 1926, the USGA introduced a newly designed trophy that is still in use today. (Both, Emory MARBL/Sidney Matthew Collection.)

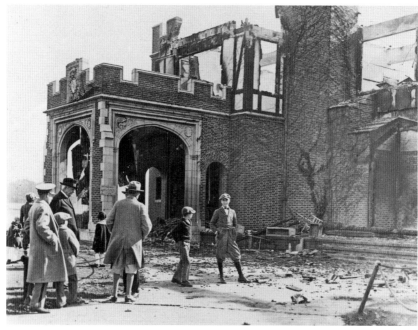

THE ATLANTA ATHLETIC CLUB AT EAST LAKE

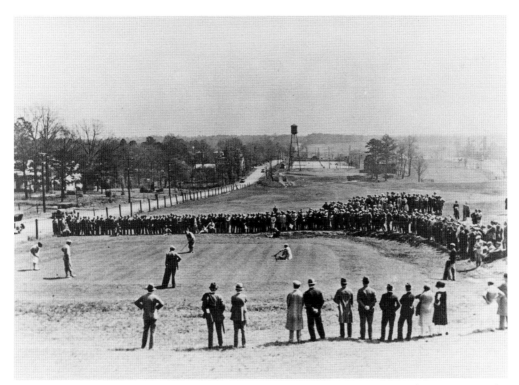

The Southern Open was held at East Lake in 1919, 1920, and again in 1927, when it was won by Jones. This image shows Gene Sarazen putting as cars motor along Alston Drive. At that time, Alston was still a dirt road. The new East Lake clubhouse can be seen in the distance in the upper-right corner. (Emory MARBL/Sidney Matthew Collection.)

Another of East Lake's champions was Charlie Yates. Yates grew up across from the East Lake course and would sneak over to watch his idol Bobby Jones play. Young Yates referred to the game as "playing Mr. Bobby." In 1926, at age 12, Yates won his first junior tournament at Candler Park with a score of 55 over 12 holes. (Sidney Matthew.)

THE EAST LAKE GOLF CLUB

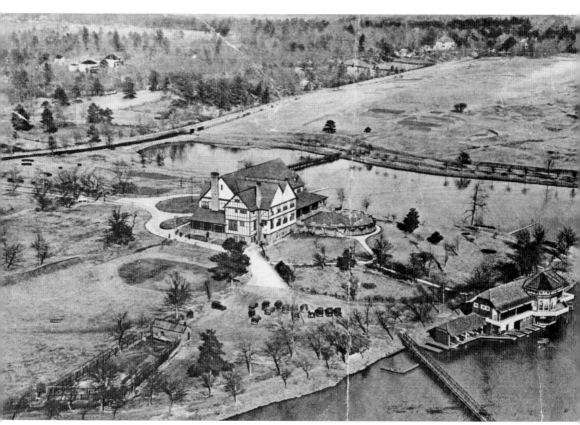

This late-1920s view of East Lake from club manager Scott Hudson's archives was taken from an airplane. The course had become so popular that members were complaining that it had become overcrowded. In 1928, the club purchased undeveloped land to the west, across Second Avenue, to build a second course. Hudson had originally objected to the purchase, feeling it would stretch the club's finances too thin. When membership voted to approve the expansion, he hired Donald Ross to design the new course. The original layout also included a lake, which was never built. Hudson served as East Lake's manager from 1915 until 1946. (Sidney Matthew.)

Atlanta was growing rapidly as a city in the early 1900s. While East Lake was once considered remote for Atlantans, by the 1920s that was no longer the case, as it was easy to access now by automobile and streetcars. In 1928, the city of East Lake was annexed into the city of Atlanta. (Sidney Matthew.)

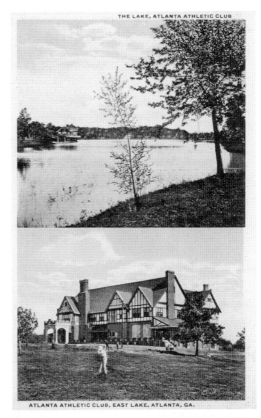

THE LAKE, ATLANTA ATHLETIC CLUB

The Yates family became a golfing dynasty at East Lake. Charlie Yates (right) won the inaugural Georgia State Amateur championship in 1931, a win that became almost a family tradition. Younger brother Dan Yates Jr. (left) won the Georgia State Amateur in 1939. Dan's son Danny Yates III claimed the Georgia State Amateur championship in 1977, 1989, and again in 1996. (Sidney Matthew.)

ATLANTA ATHLETIC CLUB, EAST LAKE, ATLANTA, GA.

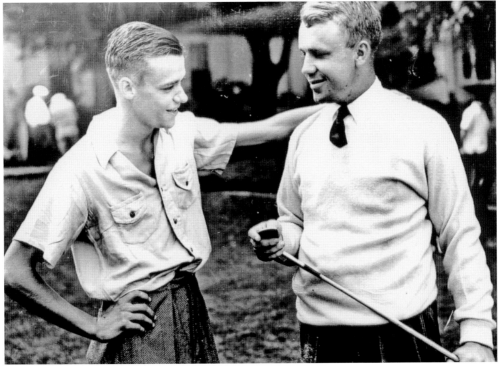

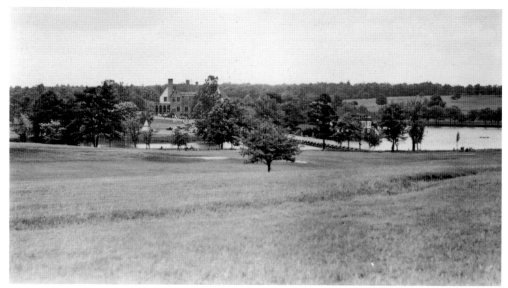

In response to the Athletic Club's popularity, members passed a charter amendment in 1931 to issue stock to its members. The 1,500 shares of capital stock represented "the ownership of the net assets of said club upon liquidation." The equities included the Downtown Athletic Club property and the East lake Country Club. Later, charter amendments expanded the number of shares to 2,500. (East Lake Golf Club.)

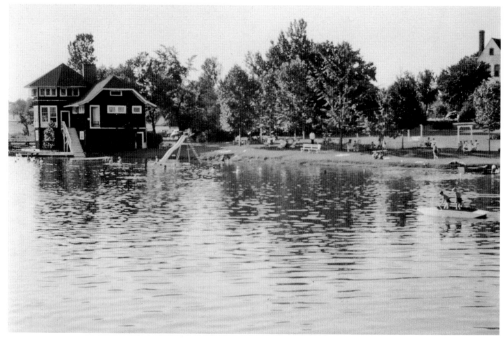

During the summer months, the lakeside beach was teeming with swimmers. Rules limited the number of guests to two, and each one was required to register beforehand. Offenses brought fines and even membership suspension. Boats could be rented for 25¢ an hour. The boathouse itself featured changing rooms and meeting rooms upstairs. (East Lake Golf Club.)

When Stewart Maiden departed in 1932, Englishman George Sargent was brought to East Lake by Bobby Jones. Sargent's prior prestigious positions included Scioto and Interlachen. He remained at East Lake until his retirement two decades later. He came with an impressive list of tour victories, including the 1909 US Open, the 1912 Canadian Open, and the 1918 Minnesota State Open. Sargent joined the Professional Golfers Association of America as a founding member in 1916. He later became the organization's president. Sargent's three sons, Alfred, Harold, and Jack, were also accomplished golfers. Harold succeeded his father as East Lake professional after George's retirement. (Both, East Lake Golf Club.)

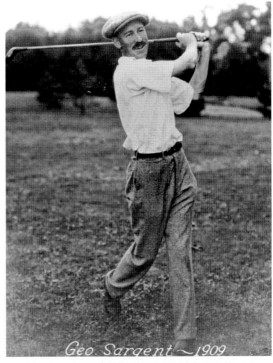

Geo. Sargent ~ 1909

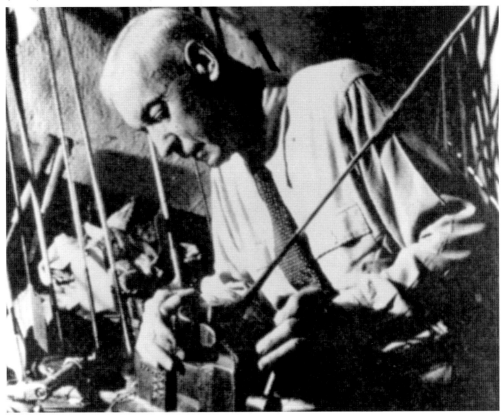

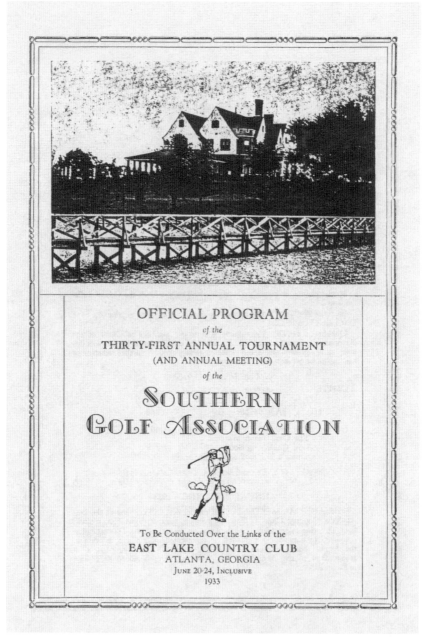

OFFICIAL PROGRAM
of the
THIRTY-FIRST ANNUAL TOURNAMENT
(AND ANNUAL MEETING)
of the

Southern Golf Association

To Be Conducted Over the Links of the
EAST LAKE COUNTRY CLUB
ATLANTA, GEORGIA
June 20-24, Inclusive
1933

East Lake hosted the Southern Golf Association Tournament for the fifth time in 1933. This program lays out the rules for the competition. The entry fee was just $5. The winner of the tournament had his name engraved on the George W. Adair Memorial Trophy; the cup was named for the late AAC president, who had died in 1921. "The most artistic cup in the United States" is passed on each year and is housed at the winner's home club. It was first awarded in 1922 and had only 11 names on it, including Robert T. Jones in 1922, Perry Adair in 1923, Jack Wenzler in 1924, Glenn Grissman in 1925, R.E. Spicer Jr. in 1926 and 1930, Harry Ehle in 1927, Watts Gunn in 1928, Sam Perry in 1929 and 1932, and Chasteen Harris in 1931. (East Lake Golf Club.)

When the Georgia Women's Golf Association (GWGA) held its 1933 tournament at East Lake, Dorothy "Dot" Kirby was just 13 years old. She became the youngest female golfer ever to win a state championship. Kirby won six Georgia State Amateur championships, the last coming 20 years later in 1953. In 1934, at age 14, Kirby entered her first women's US Amateur golf championship. She was the runner-up to Betty Jameson in 1939 and to Louise Suggs in 1947, and in 1951, Kirby won the US Amateur. (Sidney Matthew.)

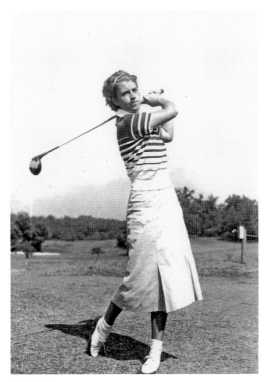

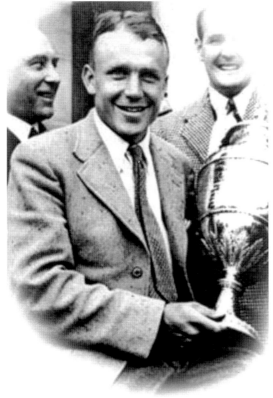

In 1936, East Lake became the only American golf course in history to produce two British Amateur champions. Charlie Yates claimed the title that his mentor and friend Bobby Jones had won six years earlier when Jones won the Grand Slam. No other club holds this distinction. (Sidney Matthew.)

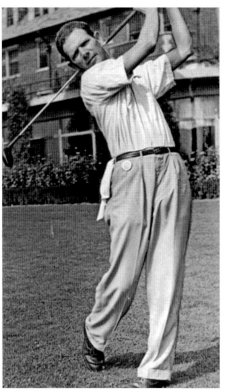

Another Bobby Jones protégé, Tommy Barnes, claimed the Atlanta City Amateur title in both 1936 and 1937. Barnes captured the Georgia State Amateur title in 1941 and qualified for the US Amateur 16 consecutive times. He went on to earn a host of other titles, taking the 1938 and 1946 Southeastern Amateur, 1946 Southeastern PGA Open, and the 1947 and 1949 Southern Amateur, as well as the Pan-Am title in 1944 while serving in the US Navy. (Sidney Matthew.)

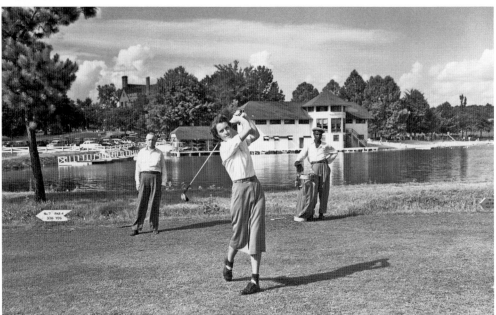

When the Georgia Women's Golf Association championship returned to East Lake in 1942, Atlanta native Louise Suggs took the title at the age of 18. She claimed her first GWGA title in 1940 when she was only 16. Suggs won 61 titles in her career and was also one of the 13 founding members of the LPGA Tour. (Florida State Archives.)

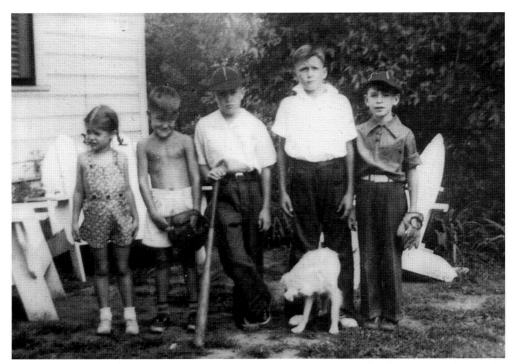

Entire families enjoyed the numerous activities available at East Lake. A photograph from the early 1940s shows, from left to right, Louise Cousins, Tom Cousins, Jim Harrison, Bill Cousins, and Charlie Harrison. The Cousinses and the Harrisons are biological cousins. Charlie Harrison became a top golfer in Georgia, and Tom Cousins rescued East Lake in the 1990s. (Charles Harrison.)

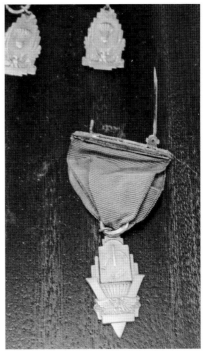

The Atlanta Athletic Club held numerous competitions and awarded medals accordingly. These medals are only a few of the many won by Charlie Harrison over the years at East Lake. The bottom one, the gold horseshoe, was won by his dad, Jim Harrison Sr., and his uncle Ike Cousins in 1944. The top medals were awarded for badminton. (Charles Harrison.)

THE EAST LAKE GOLF CLUB

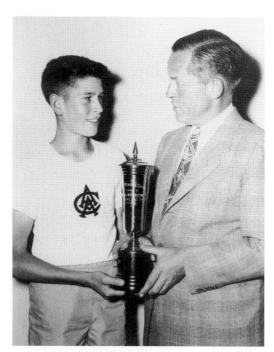

Charlie Harrison was a champion athlete in many disciplines. His favorite sport as a child was swimming. When he won the Atlanta Junior Golf Championship at age 13, he had only been playing the sport for a year. The trophy Bobby Jones is awarding him with here is actually for gymnastics. (East Lake Golf Club.)

Charlie Harrison learned to play golf with his father's hand-me-down, wooden-shafted clubs. Three years after picking them up for the first time, he won the Atlanta City Junior Amateur championship. His AAC victories included 10 club championships (nine of them at East Lake) as well as six club championships at the Atlanta Country Club. Harrison also triumphed at the 1955 Southern Amateur and the 1959 Georgia State Amateur tournaments. (Sidney Matthew.)

Harold Sargent replaced his father, George Sargent, when the elder Sargent retired from running the club in 1947. The decision to promote Harold stemmed from Bobby Jones's recommendation, who was president of the Atlanta Athletic Club at the time. Harold gained his greatest accolades from his innovations in changing the business side of golf. (Sidney Matthew.)

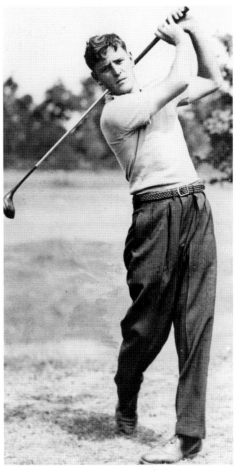

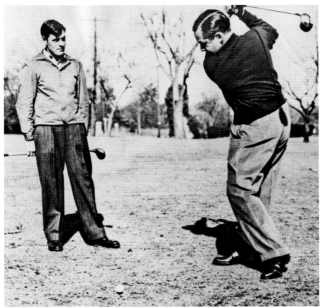

In addition to helping reshape the East Lake Club, Harold Sargent had an impact on the entire PGA. Thirty years after his father served as PGA president, Harold also became president, holding the post from 1958 to 1960. While there, Sargent implemented changing from a match-play format to a stroke-play format. He also started a pension program for PGA employees. In this photograph, Sargent is admiring Bobby Jones tee off at East Lake. (Sidney Matthew.)

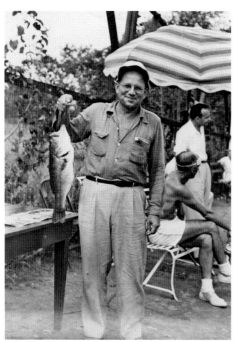

East Lake was kept well stocked with bass, bream, and catfish, and only club members were allowed to drop their lines. Here, Bill Rocker displays his catch. The *Atlanta Constitution* published a story about a 15-pound bass that would jump from the water in the mornings to taunt golfers, but the fish, if it ever truly existed, was never caught. A record catch came in 1948, when Walter Pendleton pulled in a bass weighing 10 pounds, four ounces. (East Lake Golf Club.)

Periodically, as shown in this 1960 photograph, the 18-foot-deep lake was drained, cleaned, and restocked. Records confirm that 20,000 to 30,000 small fish were introduced to the lake each year. There were daily limits as to what could be caught. In the 1930s, those limits were three bass (at least 12 inches long) and 12 bream (at least five inches long). (Sidney Matthew.)

Swimming in the lake was almost as big an attraction as the golf for many. Each year, an area directly behind the clubhouse was sectioned off and used as a swimming beach. This 1945 image shows Jim Harrison (Charles's brother) serving his summer job as lifeguard (left) while his cousin Bill Cousins keeps him company on the beach. (Charles Harrison.)

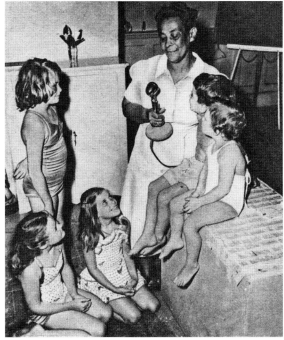

Annie Morgan operated the bathhouse for more than three decades. A club favorite, she knew all the members and their children by name. A microphone was added in the 1950s to make her job a little easier when she called out to swimmers and boaters. Pictured from left to right are Andrea Vaughn (standing), Susan LaNoue and Lela Barnhardt (kneeling), Morgan with the microphone, Rickey LaNoue, and Jill Prouty. (Charles Harrison.)

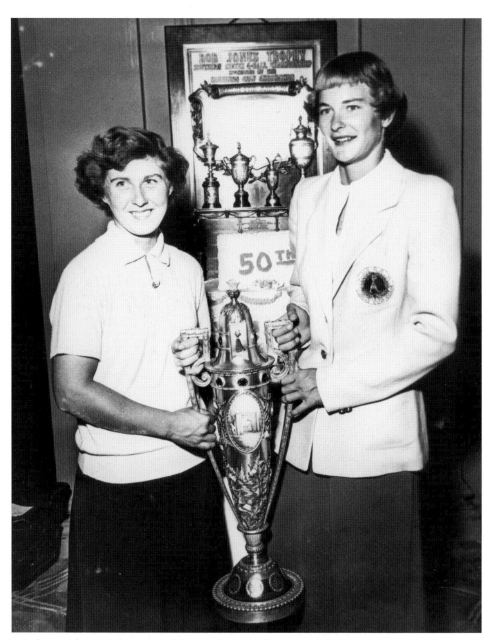

East Lake was chosen to host the golden anniversary of the women's US Amateur golf championship. Held September 11–16, 1950, a total of 110 women competed since there had been no sectional qualifying. Beverly Hanson (right) defeated Mae Murray (left) six and four in the 36-hole match. The tournament was noteworthy because it had the most extra holes ever played in the championship. Murray had defeated Fay Crocker of Uruguay on the 27th hole in the fourth round after nine extra holes. Hanson and Murray are seen here with the trophy, which was presented by Bobby Jones. Names of Atlantans already inscribed on the trophy included Alexa Stirling and Louise Suggs. It marked the first time a USGA national championship was ever played in Atlanta. The LPGA was also formed in 1950. (East Lake Golf Club.)

In the early 1950s, Charles Cooper Jr. was the athletic director charged with keeping members' children busy during the summer—by all accounts, he succeeded. The usual competitions in swimming, badminton, boating, horseshoes, and the like continued, but there were also new activities such as camping, cookouts, and sack races. These photographs, taken for the AAC's newsletter, give an indication of how popular the summer activities were for kids. The undated photograph above shows one of the awards ceremonies held at the end of the summer. The image below shows a group of unidentified children showing off for the camera at the lake's edge. (Both, Atlanta Athletic Club.)

The open-air dining terrace on the lower level was enclosed in the late 1940s, and the men's locker room was moved downstairs. The facility featured 820 lockers, two sets of showers, and card tables. The golf shop and the men's grill were next door. Above it all was a new concrete terrace. The main dining area opened up to a vast expanse used for entertaining. Saturday night dances under the stars were popular with members. The 1954 photograph below features Dean Hudson and His Orchestra, known for the signature song "Moon Over Miami." Hudson relocated to Decatur in the 1940s and was popular among all of the Atlanta-area country clubs. (Both, East Lake Golf Club.)

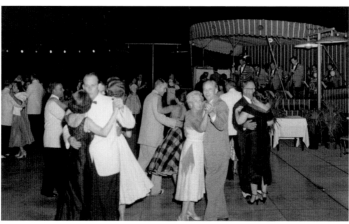

Bird's-Eye .. X-Ray View of the East Lake Country Club

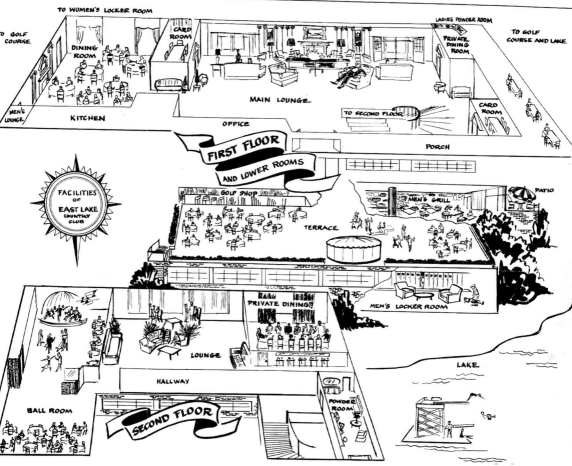

This image gives a better sense of just how the club could be utilized after the expansion of the terrace and the huge men's locker room located below. The "X-Ray View of the East Lake Country Club" depiction was not to only educate present members about the changes but also to help attract new members to enjoy the modern facilities. The first floor included the main common area, as well as two small rooms for those who wanted to play cards or have meetings. Upon entry, the main dining area was to the left, but there was also a private dining room that could be reserved. The second floor was largely used for special events and included a ballroom as well as another private dining space. (Charles Harrison.)

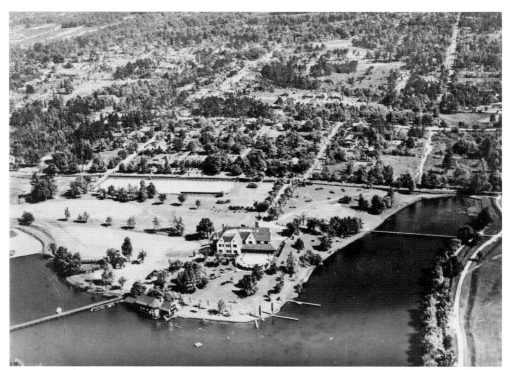

The 28-acre East Lake was home to boating, fishing, and swimming for decades, but by the late 1950s, the growing membership made it clear to the board that it needed a real swimming pool. Work began in 1958 on a *T*-shaped pool on land directly behind the club. It was 162 feet, two inches long and 82 feet, two inches wide, and the depth went from 12 feet in the diving area to three feet in the shallow end. There was a separate, 20-square-foot wading pool that was a foot deep. A bathhouse and snack bar were built beneath the pool, near the locker room. On June 1, 1958, the new pool opened at East Lake. (Both, Atlanta Athletic Club.)

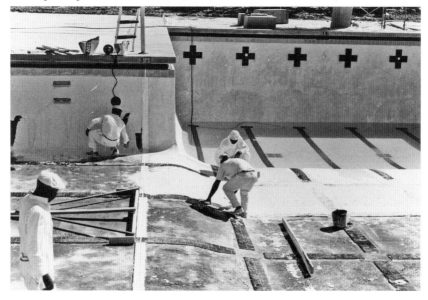

The lake was closed to swimming, although the beach area directly below it was left open to allow children to play in the water. The decades-old boathouse that was built when the AAC moved to East Lake was torn down to make way for longer docks and boating facilities. (East Lake Golf Club.)

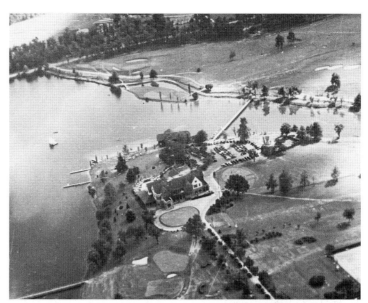

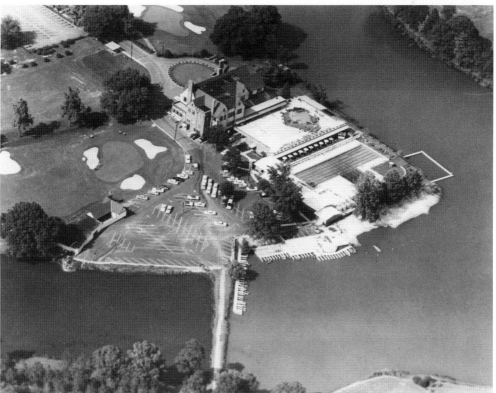

This aerial view shows just how much area the new pool and its facilities included. The No. 9 and No. 10 greens are to the west. The new pool allowed the club to expand its ability to offer swimming classes. The AAC also began to host intra-city swimming meets against other Atlanta area clubs. Records show that on some days up to 500 people used the new pool and its facilities. (East Lake Golf Club.)

Bill Hare Jr. considered himself a baseball player when his family joined East Lake in 1958. He soon changed his sport of choice after learning to play golf. He often brought his fraternity brothers from Georgia Tech to play. After graduating college, Hare applied for his own membership to East Lake. (Bill Hare.)

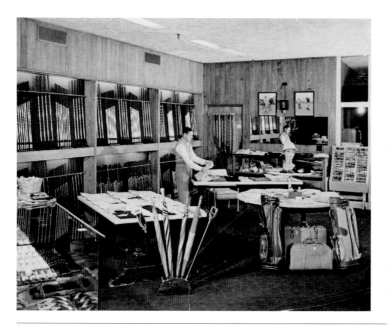

When East Lake Golf Club expanded the men's locker room in the 1950s, the pro shop also got a complete makeover. The expanded and modernized shop was relocated to the lower level and was adjacent to the new men's locker room. It also overlooked the No. 1 tee to make it convenient for golfers. (East Lake Golf Club.)

The 15th Biennial Ryder Cup matches were held at East Lake on October 13–15, 1963. The tournament was awarded to East Lake through the efforts of Harold Sargent, who was president of the PGA. Having the legacy and presence of Bobby Jones also played an important role. Sargent commended Jones, saying, "He carried the name of East Lake with him to many countries, and his indeterminable contributions to golf are rewarded in a small way by playing the matches here." To create a tournament-worthy challenge, George Cobb renovated the entire course, and many of the holes were changed. East Lake was the first golf course in Atlanta to install bentgrass putting greens. (Both, Sidney Matthew.)

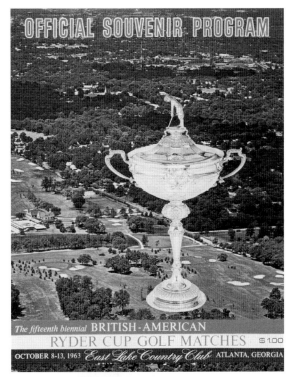

OFFICIAL SOUVENIR PROGRAM

The fifteenth biennial BRITISH-AMERICAN
RYDER CUP GOLF MATCHES $1.00
OCTOBER 8-13, 1963 East Lake Country Club ATLANTA, GEORGIA

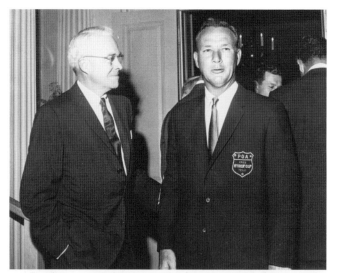

The 1963 US Ryder Cup team was captained by 24-year-old Arnold Palmer, the last time the United States had a playing captain. This was Palmer's second Ryder Cup competition. He played on six Ryder Cup teams: 1961, 1963, 1965, 1967, 1971, and 1973. He was captain again in 1975. Palmer (right) is shaking hands with Atlanta mayor Ivan Allen. (East Lake Golf Club.)

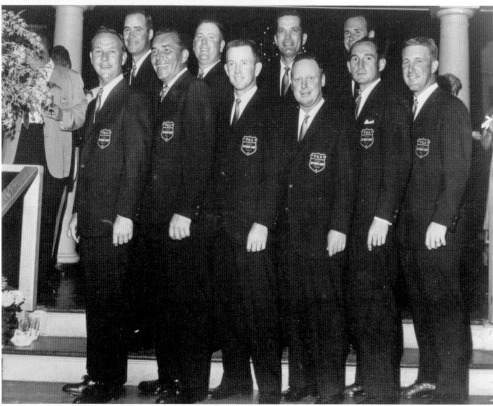

The 1963 US Ryder Cup team poses here on the steps of East Lake. Pictured are, from left to right, (front row) Arnold Palmer, Julius Boros, Gene Littler, Billy Maxwell, Dow Finsterwald, and Dave Ragan Jr.; (back row) Johnny Potts, Billy Casper, Bob Goalby, and Tony Lema. Nonplaying captain John Fallon led the British team, which included Brian Huggett, Peter Alliss, Neil Coles, Dave Thomas, George Will, Christy O'Connor, Bernard Hunt, Tom Halliburton, and Geoffrey Hunt. (Sidney Matthew.)

The official competition lasts three days. Monday and Tuesday prior to official play featured other matches. Monday's Pro-Am featured East Lake's own Charlie Harrison shooting 70, leading his team to victory with a net score of 59. His team captain, Julian Boros, scored so poorly that he did not turn in an individual scorecard. (Sidney Matthew.)

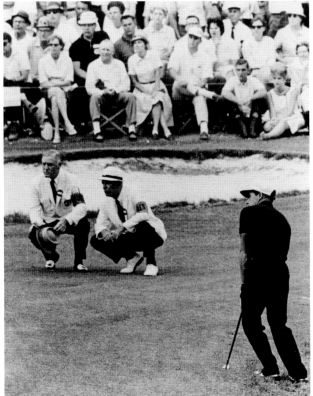

South African golfer Gary Player was ineligible to be a member of the British Ryder Cup team. He attended the cup as a contestant in the Pro-Am competition. Player established a new course record for tournament play, scoring 66 by birdying all four of the par-5 holes. (Sidney Matthew.)

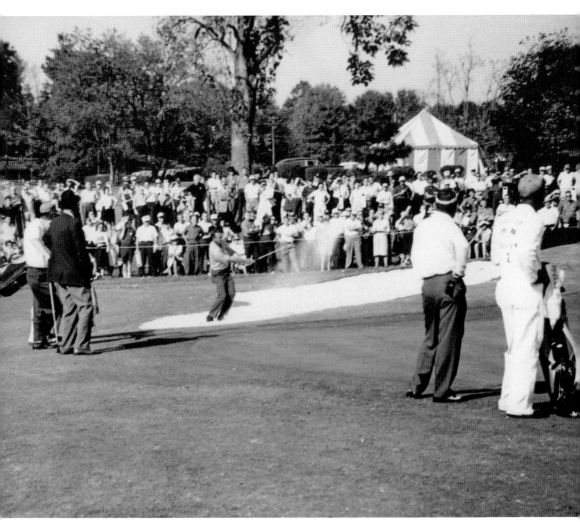

Arnold Palmer blasts from the bunker as the crowd looks on. Crowds numbered from 7,000 to 12,000 over the course of the three-day event. The winning team needed a minimum of 16 1/2 points out of 32 to retain the cup. The US team prevailed by a score of 23-9. Throughout the tournament, the Americans did not lose a single match in the afternoon sessions. One of the few bright moments for the British team came in the afternoon of the final day, when Peter Allis was able to hole a 12-foot putt on the final hole to defeat Arnold Palmer. (Sidney Matthew.)

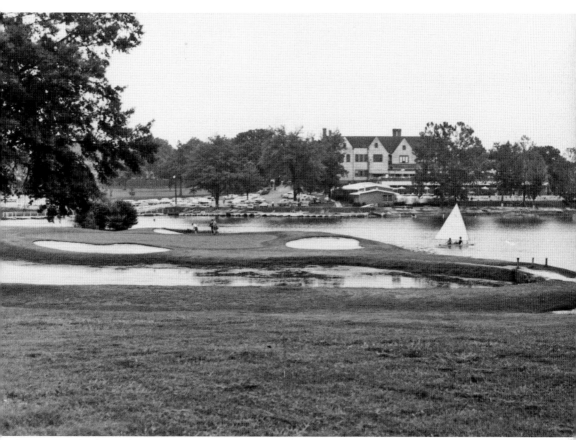

Atlanta's population was migrating to the northern suburbs and so were many of the club members. The trek down to East Lake was becoming less appealing. The AAC purchased a 600-acre tract along the Chattahoochee River in north Fulton County known as the River Bend property to build a new course. Club directors felt there was no need for two courses at East Lake. In 1965, they proposed selling the second course to help pay for upgrades at first and to cover some of the River Bend costs. When put before the membership, it voted 975 to 392 in favor of the sale. The directors stated, "All of us are committed to keep East Lake No. 1 golf course as one of America's greatest golf courses and as a golf shrine in the finest tradition." (Atlanta Athletic Club.)

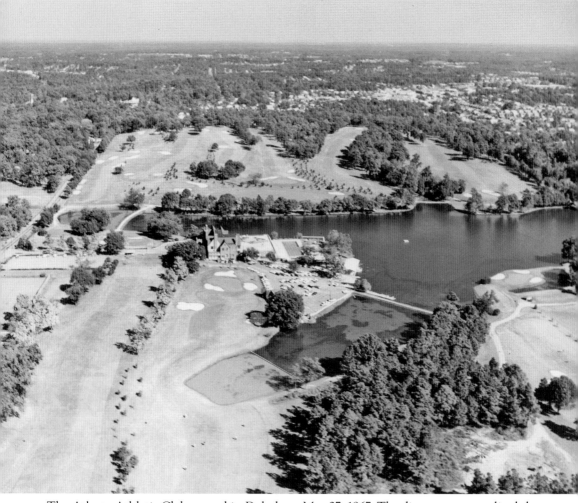

The Atlanta Athletic Club opened in Duluth on May 27, 1967. The directors soon realized the financial burden of operating two country club locations. Faced with having to significantly raise membership dues, they proposed that it was in the AAC's best interest to concentrate efforts on developing the new property and selling East Lake. On April 2, 1968, a vote was taken by the AAC stockholders, who voted 908 to 544 to sell the historic club. A group of 25 members scrambled to raise the $1.8-million asking price. On April 9, 1968, the Atlanta Athletic Club at East Lake became simply the East Lake Country Club. Some dissenting AAC voters filed a lawsuit to nullify the sale, stating it was improper because "the number voting in favor was less than a majority of the shares outstanding." Citing East Lake's legacy of being the home course to Bobby Jones, Alexa Stirling, and Charlie Yates, they claimed club directors had originally promised "to own the East Lake No. 1 course and the clubhouse perpetually." Their lawsuit failed. (Atlanta Athletic Club.)

BOBBY JONES

In the summer of 1906, five-year-old Bob Jones and his parents moved into a boardinghouse owned by Mary Meador. Located across from East Lake, the house was opposite of today's No. 10 fairway. "Little Bob" spent any free moment he could shadowing the club's assistant pro, Stewart Maiden. A fellow boarder, Fulton Colville, noticed Jones's obsession with golf and gave the youngster his first club. (Sidney Matthew.)

The youngster's first club was a "cleek," a long, shallow-bladed iron comparable to today's 3 iron or 4 wood. Jimmy Maiden cut the iron down to a child's size, and soon Bob was mimicking Maiden's every move. To occupy themselves, Frank Meador Jr. and Bob built a two-hole course in the yard and played all summer. Pictured in 1907 from left to right are Bob Jones, Perry Adair (son of AAC president George Adair), and Frank Meador Jr. (Sidney Matthew.)

The following summer, Mrs. Meador held a mini-tournament on her street with a silver cup as the prize. The three competitors were her son Frank, Little Bob, and 12-year-old Alexa Stirling, who also lived in the neighborhood. Although Alexa had a lower score, Jones was awarded the cup—Alexa is the only female to ever beat him. Jones's mother, Clara, is holding the trophy. (Sidney Matthew.)

Jones is just seven years old here as he watches his father, Robert P. Jones, teeing off from No. 14. The Mule House stood to the right of the tower in an area that is the site of the present No. 2 green. The other man identified in the image is W.H. Holloman (far right). Bob was a sickly child, so his parents were excited that he showed such interest in a sport. (Sidney Matthew.)

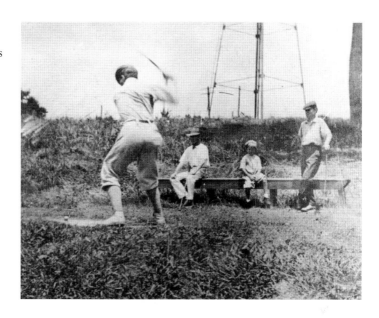

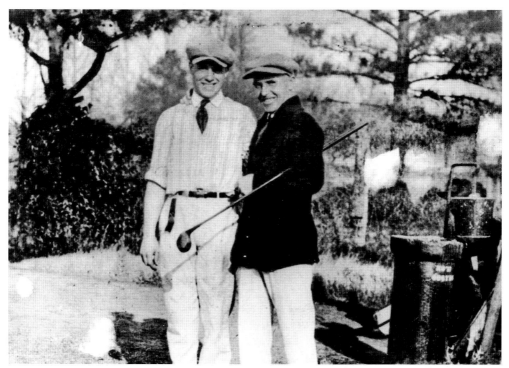

Stewart Maiden never gave Bob Jones formal lessons but enjoyed mentoring him. Historian Charles Elliot quoted Maiden as saying, "I can't do a thing for him—after five minutes, he's teaching me!" Maiden gave his protégé his first set of matched clubs, consisting of a driver, a brassie, a mid-iron, a mashie, a niblick, and a putter. (Sidney Matthew.)

THE EAST LAKE GOLF CLUB

Jones's reputed ability was already growing when in 1913 the 11-year-old shot an 80 at East Lake while playing with Perry Adair. Three years later, Jones won the first Georgia State Amateur championship, edging out Adair for the title. Bob Jones then became the youngest player to participate in the US Amateur. George and Perry Adair went with him to Merion, Pennsylvania, for the tournament. Jones would later say that the Adairs' encouragement helped give him the confidence to compete. Jones lost in the third round of that tournament to Robert A. Gardner. At left, Jones is swinging a club at age 11, and below, he is competing at Merion at age 14. (Both, Sidney Matthew.)

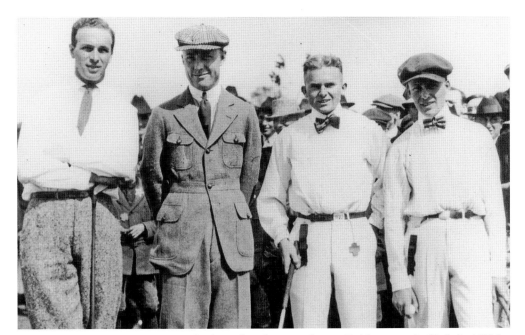

His youth at the tournaments soon had people referring to him as Bobby instead of Bob. In 1917, he again stunned the crowd when he became the youngest golfer to ever to win the Southern Amateur title. He went on to claim that championship two more times. When the Southern Golf Association Hall of Fame was established in 1972, Jones was its first inductee. Pictured from left to right are Robert A. Gardner, Charles "Chick" Evans, Perry Adair, and Bobby Jones. (Sidney Matthew.)

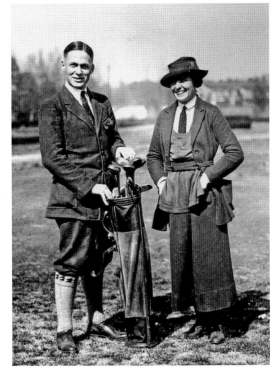

Bobby Jones was described by sportswriter Grantland Rice as having "the face of an angel and the temper of a timber wolf." He also had a colorful vocabulary from a young age. After Alexa Stirling's father overheard him unleash a litany of profanity one day, Dr. Stirling grabbed his daughter, took her home, and forbid her to be a part of any future Jones foursome. The ban lasted for two years, but the pair's friendship was lifelong. (Sidney Matthew.)

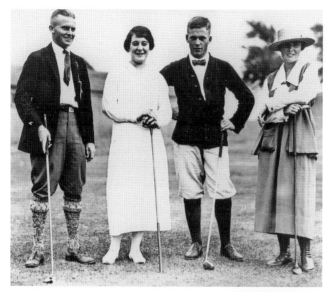

During World War I, all golfing tournaments were suspended. In 1918, East Lake's Bobby Jones, Alexa Stirling, and Perry Adair joined Elaine Rosenthal of Chicago to create a traveling exhibition golf team known as the Dixie Whiz Kids. The kids brought in $150,000 for the Red Cross and are credited with increasing golf's popularity. The group is shown here at New Jersey's Montclair Golf Club. From left to right are Adair, Rosenthal, Jones, and Stirling. (Sidney Matthew.)

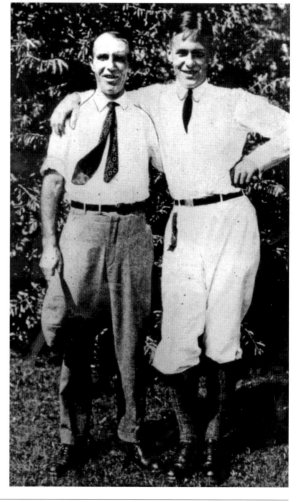

Stewart Maiden went on hiatus from East Lake, traveling to St. Louis in 1919 to host the US Amateur, but would follow Jones during many of his title matches. He was a master diagnostician of what was wrong with a swing. Jones never took a lesson from the man known as Kiltie but trusted his advice. He would seek out Kiltie if he felt he needed an adjustment. Jones would say, "Sometimes just one salty pointer could give a golfer a lot of help." (Sidney Matthew.)

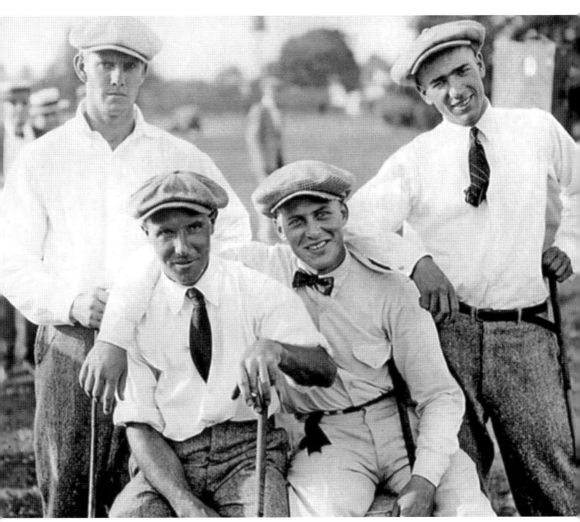

Jones made a habit of becoming friends with his competitors. This photograph is from his first US Open in 1920 at the Inverness Club in Toledo, Ohio. From left to right are Harrison Johnston (standing), Stewart Maiden, Bobby Jones, and Leo Deigel. The 1920 US Open was also the first for Gene Sarazen, Tommy Armour, and Johnny Farrell. Eight of the next 12 US Opens were won by one of these four golfers. During this appearance, Jones tied for eighth place. Ted Ray of the island of Jersey won the match. Ray was 43 years and 143 days old, making him the oldest US Open champion to that point. The record held for 66 years until Raymond Floyd won in 1986. Floyd at the time was just a few months older than Ray. (Emory MARBL/Sidney Matthew Collection.)

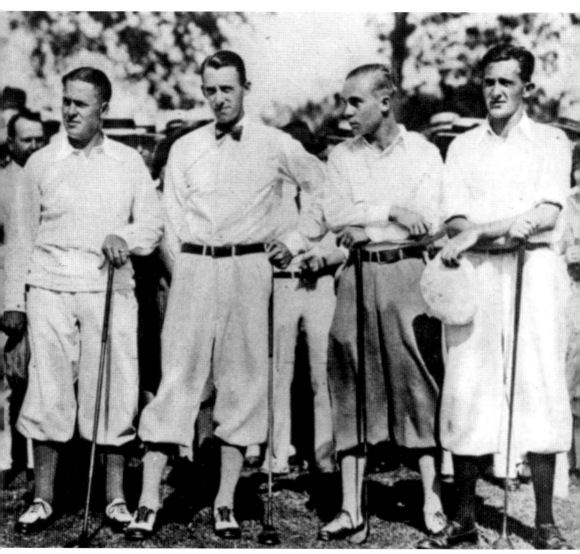

Jones was his own worst critic and, at times, enemy. A turning point in the young golfer's career came in 1921, when he played the British Open at the Old Course at St. Andrews, Scotland, for the first time. He was already frustrated after having been eliminated in the fourth round at the British Amateur in Hoylake, England, weeks earlier. St. Andrews is the birthplace of golf. His poor performance continued, and after missing a putt on the 11th hole, Jones picked up his ball and quit the tournament in frustration. Decades later, he referred to it as "the most inglorious failure of my golfing life." USGA president George Herbert Walker was incensed when Jones threw clubs in USGA competitions. He warned Jones to control his temper or face the possibility of never again playing in a USGA event. Pictured at Hoylake are, from left to right, Bobby Jones, Gordon Simpson, "Chick" Evans, and J.L.C. Jenkins. (Sidney Matthew.)

Jones played what he called the best string of golf of his life in 1922 during the Southern Amateur at East Lake. He is shown here walking with Frank Godchaux (left) of Nashville. It was noted by the press that he was wearing long pants for the competition, which covered a hip-to-ankle bandage he was wearing after surgery to repair varicose veins. (Emory MARBL/Sidney Matthew Collection.)

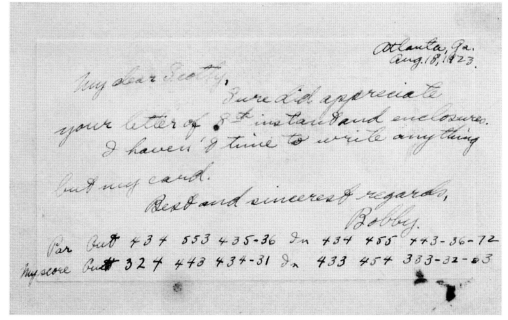

One August 23, 1923, Jones scored 63 at East Lake to tie the benchmark for the course record. For years, it was claimed that he had set a new record, but Jones's score was actually a tie. His mentor, Stewart Maiden, had shot a 63 in 1916 while a 14-year-old Bobby Jones was playing with him. This scorecard from that day in 1923 is one of the few times he signed his name as "Bobby." Dr. Linton Hopkins's book *Where Bobby Learned to Play* chronicles the course record history in detail. (Sidney Matthew.)

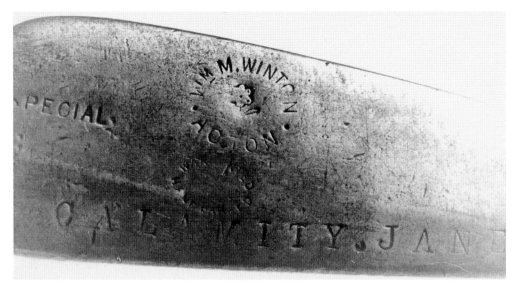

Just prior to the 1923 US Open, Jimmy Maiden gave Jones a putter that most golfers would likely have turned down. Jones would say later, "It was rusty and sort of beat-up, and no doubt had several owners before it ever got to me." Maiden had named it Calamity Jane after the female hero from the American Wild West. (Sidney Matthew.)

At 33 1/2 inches, Calamity Jane was shorter than most putters and weighed just 15 1/2 ounces. Its wooden shaft was mended more than once with glue and black linen whipping. Despite its fragile appearance, the somewhat crooked putter helped Jones win his first three majors and became the club every golfer copied. Jones kept the putter with him whenever he traveled, even claiming to sleep with it. (Sidney Matthew.)

BOBBY JONES

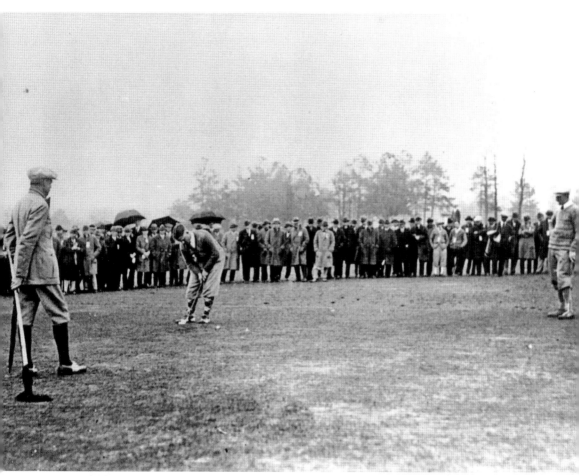

Jones won the US Open in 1923. In April 1924, he faced reigning British Open champion Arthur Havers at East Lake. The match was billed as an "unofficial world championship." While Jones outdrove his opponent, his overall game was uncharacteristically inconsistent. Havers defeated him 2 and 1, handing Jones his first defeat at East Lake since he was 13 years old. The *Chicago Tribune* reported that Jones "fought valiantly for the match," but in the final holes he was "unable to overcome the commanding lead which Havers piled up due to Bobby's erratic state." The paper also reported that the match "furnished some of the most spectacular golf ever seen on a local course." Jones is shown putting on the No. 6 green (the island hole) during the match. (Sidney Matthew.)

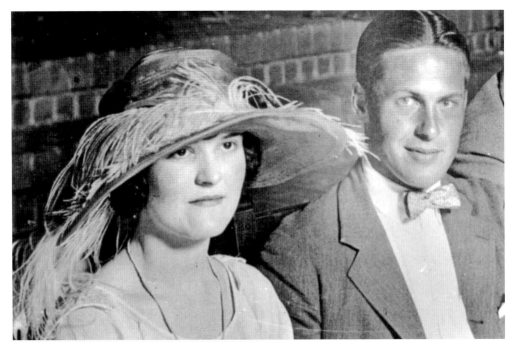

As a freshman at Georgia Tech in 1919, Jones met Mary Rice Malone and began dating the fellow Atlanta native. The photograph above shows the couple at their engagement party, held at the East Lake Country Club. The *Atlanta Constitution* reported that Miss Malone was a member of the Junior League, graduated from Washington Seminary, and had made her debut in 1921–1922. The couple married at the Druid Hills home of her parents, John and Mamie Malone, at 8:30 p.m. on June 17, 1924. Fr. James Horton of Sacred Heart Catholic Church performed the ceremony. The maid of honor was Katherine Haverty, and the best man was Richard Garlington. The couple honeymooned at the Grove Park Inn in Asheville, North Carolina, before returning to Atlanta to live with Jones's parents. In the wedding photograph below, the woman to the right of Bobby and Mary Jones is Katherine Haverty. (Both, Sidney Matthew.)

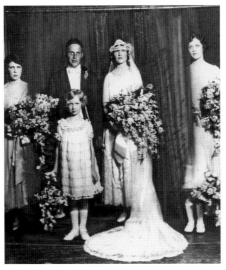

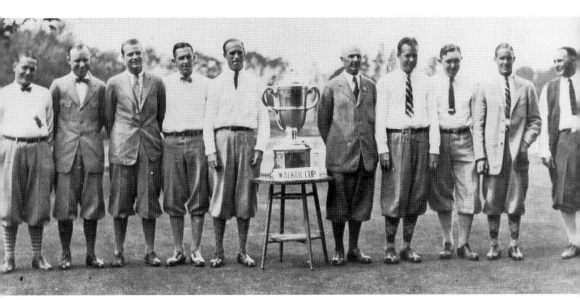

The USGA and the Royal and Ancient Golf Course in Great Britain initiated a tournament in 1922 that would pit the top amateurs of the United States against the top amateurs of Great Britain and Ireland. It was called the Walker Cup, named after USGA president George Herbert Walker, grandfather and namesake of Pres. George H.W. Bush. Jones played on the US Walker Cup team five times, winning nine of his 10 matches. In 1924, the United States won all of the matches in which he played at the Garden City Club on Long Island, New York. Pictured here are, from left to right, Bobby Jones, Chick Evans, Jess Sweetser, Francis Ouimet, Bob Gardner, W.C. Fownes Jr., Max Marston, Jesse Guilford, Harrison Johnston, and Dr. O.F. Willing. (Sidney Matthew.)

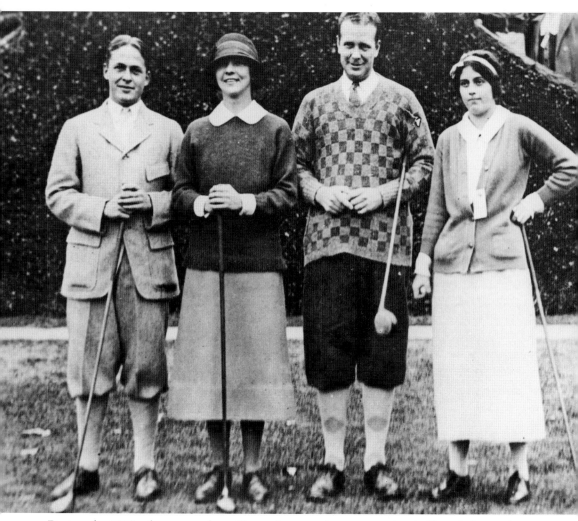

During the 1920s, these were the golfers to beat on the amateur circuit. From left to right are Bobby Jones, Glenna Collett, Max Marston, and Edith Cummings. Collett was often called "the female Bobby Jones." In 1924 alone, she won an astonishing 59 of 60 matches. She collected a record six women's US Amateur championships, two women's Canadian Amateurs, and a women's French Amateur. Marston defeated Jones in the 1923 US Amateur. He also took the New Jersey State Amateur in 1915 and 1919 and the Pennsylvania State Amateur in 1921 and 1922. Marston played on the US Walker Cup teams four times. A Chicago socialite, Cummings competed in the 1921 women's British Amateur and won the 1923 women's US Amateur. F. Scott Fitzgerald based *The Great Gatsby* character Jordon Baker on Cummings. (Emory MARBL/Sidney Matthew Collection.)

For the 1925 US Amateur, two players from the same club faced off for the first and only time in tournament history. Bobby Jones and his friend Watts Gunn went head to head in the match. Gunn set the world record for international championship golf by winning 15 straight holes in the first round of the 36-hole match. In the end, though, Jones took the US Amateur crown. (Sidney Matthew.)

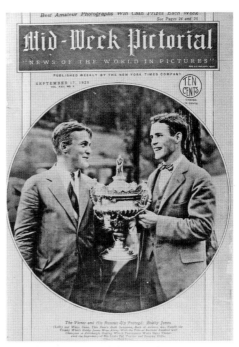

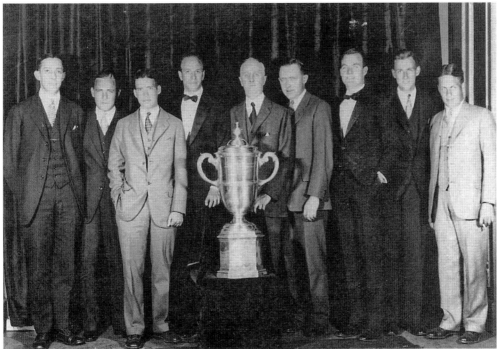

The 1926 Walker Cup was Jones's second. Joining him on the team was fellow East Lake Golf Club member Watts Gunn. Played on the Old Course in St. Andrews, the United States beat Great Britain 6-5. The team is pictured here with its trophy. From left to right are Francis Ouimet, George Von Elm, Gunn, Robert A. Gardner, William C. Fownes, Jesse Guilford, Jess Sweetser, Roland McKenzie, and Jones. (Sidney Matthew.)

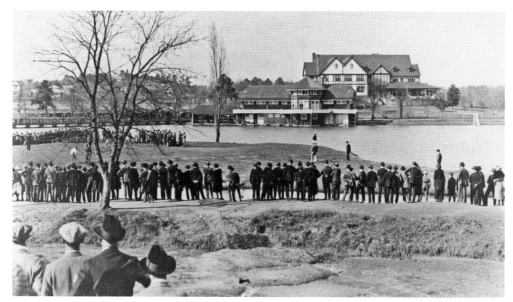

In 1927, the Southern Open was held for a third time at East Lake. Bobby Jones triumphed, narrowly edging out his friend and rival Watts Gunn. That same year, Jones won his second British Open at the Old Course on the Royal and Ancient Golf Club of St. Andrews, Scotland. (Emory MARBL/Sidney Matthew Collection.)

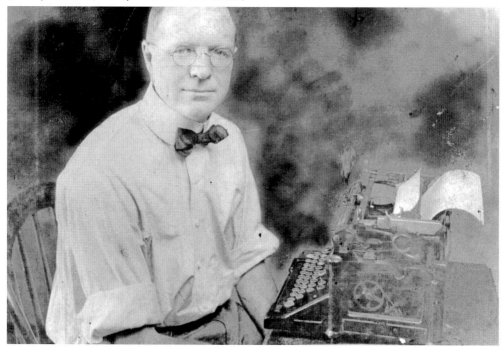

O.B. Keeler was a sportswriter for the *Atlanta Constitution* when he first recognized that Bobby Jones was going to make a lasting impact on the world of golf. Keeler became the first sportswriter to go on the road with a major athlete, traveling more than 150,000 miles with Jones to every major championship he won. (Sidney Matthew.)

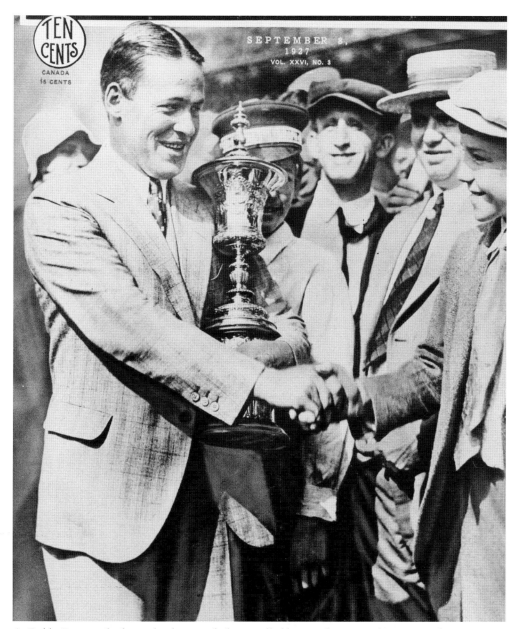

As Bobby Jones racked up titles, his popularly propelled him to the cover of magazine after magazine. In 1927, he won his third US Amateur championship, and his photograph graced the cover of this issue of the *Mid-Week Pictorial*. He is seen here holding his trophy and shaking the hand of 14-year-old Charlie Yates. Yates grew up across the street from East Lake and would slip away from home so he could watch his hero play golf. Jones mentored Yates, and the two played together often. Yates became another of the champions of East Lake. He won the Georgia State Amateur in 1931 and 1932, the Western Amateur in 1935, and the 1938 British Amateur. Yates played on two Walker Cup teams in 1936 and 1938 and captained the 1953 team. (Sidney Matthew.)

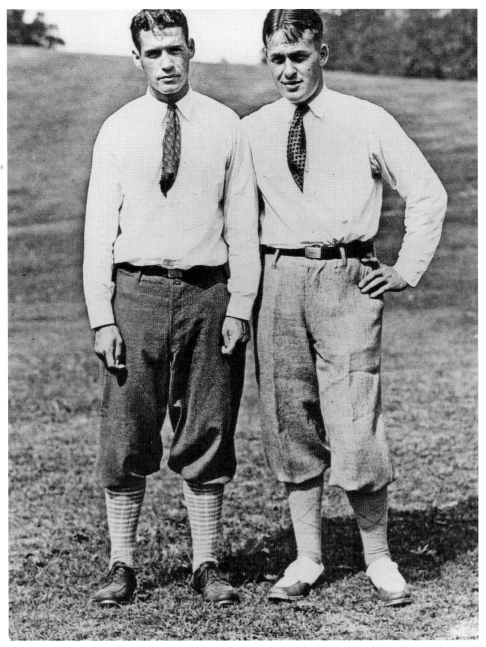

When the 1928 Walker Cup was played at the Chicago Golf Club in Wheaton, Illinois, two East Lake champs were again together on the US team. Bobby Jones was the captain, while Watts Gunn joined teammates Charles Evans Jr., Harrison R. Johnson, Roland R. MacKenzie, Francis Ouimet, Jess Sweetser, and George Von Elm. The 1926 and 1928 Walker Cups marked the only times in cup history that two team members were from the same home club. The United States beat the British 6-5. The British team was captained by Dr. William Tweddell and included John B. Beck, Ronald Hardman, Maj. Charles Hezlet, William Hope, Dr. A.R. MacCallum, Capt. G.N.C. Martin, T. Phillip Perkins, Edward Storey, and T.A. Torrance. (Sidney Matthew.)

Jess Sweetser (left) was on the original US Walker Cup team in 1922. He played on six Cup teams; three of those were with Bobby Jones. Sweetser won the US Amateur in 1922, defeating Jones. In 1926, he became the first American-born golfer to win the British Amateur. (Sidney Matthew.)

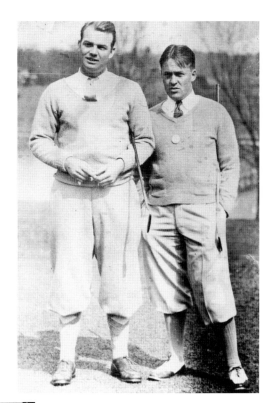

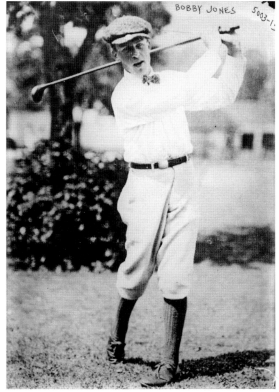

For as many rounds of golf Bobby Jones played in his lifetime, he only made two aces. His first hole in one came in 1927 on the 173-yard No. 11 at East Lake. His second was on January 13, 1932, on the 145-yard (at the time) No. 14 at Augusta Country Club. (Library of Congress.)

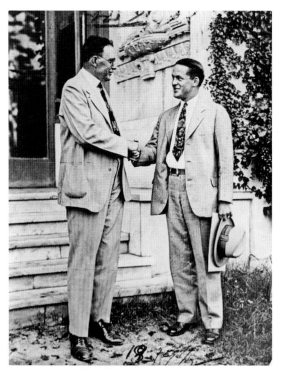

Jones's golf talents were perhaps only surpassed by his intellect. Having graduated from Georgia Tech, he continued his studies to obtain an English degree in 1924 from Harvard. He then enrolled in Emory's law school in 1927, and after just one year, he took the bar and passed. He is shown here on the right being congratulated by the dean of Emory University's law school, Charles J. Hilke. (Emory MARBL/Sidney Matthew Collection.)

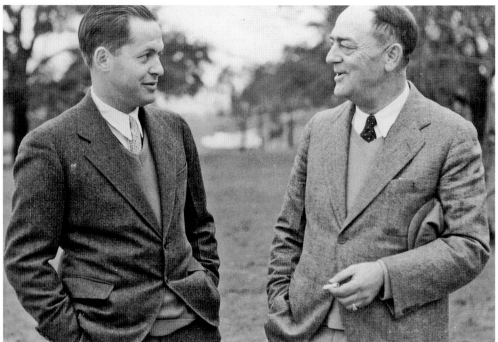

Upon passing the bar, Jones (left) joined his father's law practice at the firm of Jones, Evins, Powers, and Jones in Atlanta. Robert P. Jones (right) was a founding partner of the firm in 1893. Despite his numerous successes in golf, the younger Jones kept his office virtually devoid of any golf memorabilia. (Sidney Matthew.)

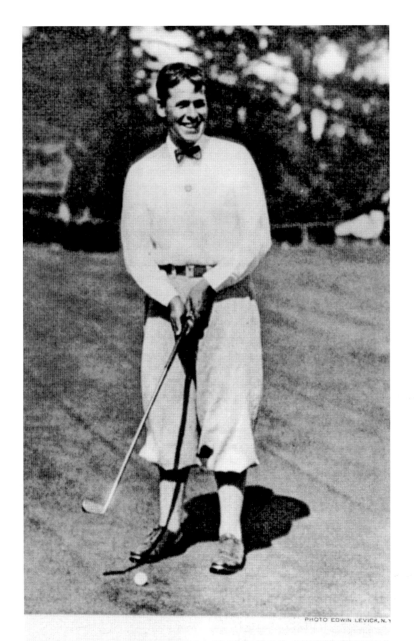

Robt T Jones Jr

While the public knew him as Bobby Jones, his friends knew him simply as Bob. He also went by the name Robert Jones Jr., even though his middle name was Tyre and his father was Robert Purmedus Jones. When he and Mary had their son, they named him Robert Tyre Jones III. When signing autographs or papers, Jones would generally pen his preference of "Robert T. Jones Jr." There were rare instances when he signed with his public persona of "Bobby Jones." (Sidney Matthew.)

THE EAST LAKE GOLF CLUB

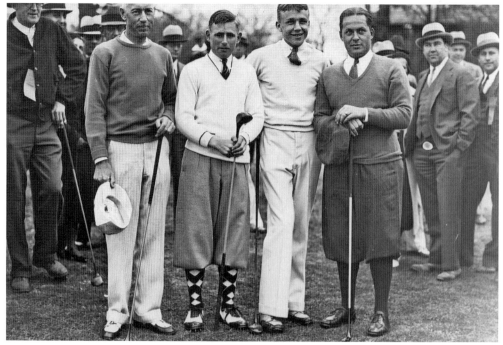

With the 1928 Summer Olympic Games taking place in the Netherlands, efforts were under way to help raise money to support US athletes. An Olympic Games Fund benefit match was held at the East Lake Golf Club. Among those participating that day were, from left to right, George Sargent, Errie Ball, Charley Yates, and Bobby Jones. (Sidney Matthew.)

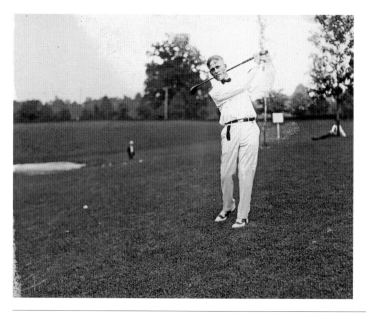

Jones's golfing reputation grew rapidly, although he did not consider himself a full-time golfer. By 1930, he was clearly on a streak. Just the year before, he had captured the US Open at Winged Foot Golf Club in Maraoneck, New York. He also captained the 1930 US Walker Cup team when it beat the British 10-2 at the Royal St. George's Golf Club. (Library of Congress.)

Jones secured his place as a golf legend in 1930. On May 31, he won what was his only British Amateur championship at St. Andrews. He called it "the most important tournament of my life." Back home at East Lake Golf Club, the second course was opened to coincide with his victory. (Sidney Matthew.)

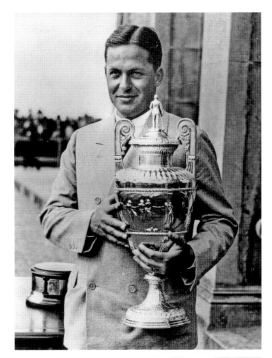

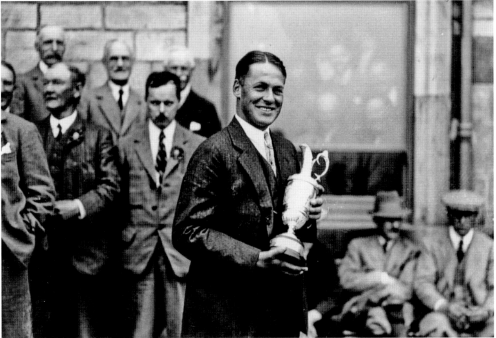

From St. Andrews, Jones traveled on to Royal Liverpool Golf Club in England, host of the British Open. The tournament took place June 18–20. After struggling in the final round, he was able to outplay Macdonald Smith and Leo Diegal by two strokes. The victory meant Jones was the first player since John Ball in 1890 to win both the British Amateur and British Open in the same year. (Sidney Matthew.)

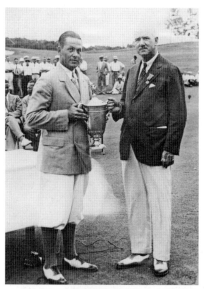

After conquering Britain, Jones sailed back to the United States and to the Interlachen Country Club in Minnesota. The competition on July 10–12 was played in oppressive heat with temperatures topping 103 degrees Fahrenheit. Jones was able to successfully defend his title. His final score of 287 was one stroke off the US Open record. Here, Jones (left) receives his trophy from USGA president Findlay Douglas. (Emory MARBL/Sidney Matthew Collection.)

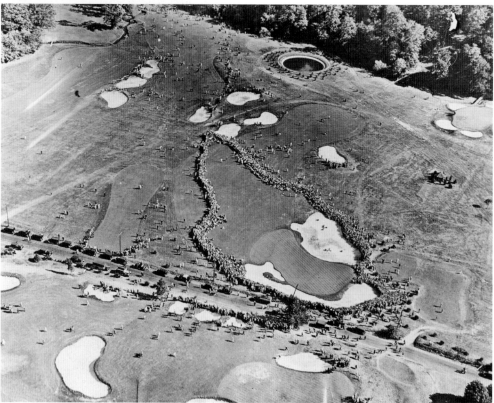

Jones returned to Atlanta for a four-week rest before setting his sights on his next quest, the US Amateur. By the time he made it to the Merion Golf Club in Ardmore, Pennsylvania, the excitement was building. There was a real possibility that the young Georgia golfer could do the unthinkable and win all four of the world's top golf competitions. Unprecedented crowds turned out to watch the matches. (Emory MARBL/Sidney Matthew Collection.)

Bobby Jones loved playing Merion. His first tournament there was when he was just 14 years old. He had won the US Amateur four times previously, and he knew the course well. He breezed through the early rounds and dominated the 36-hole final, securing an 8 and 7 victory to win the unprecedented Grand Slam. Jones (left) receives his trophy again from USGA president Findlay Douglas (right). (Sidney Matthew.)

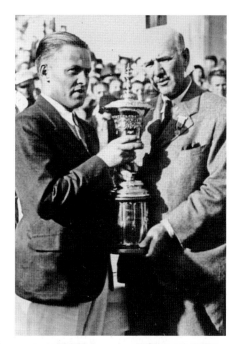

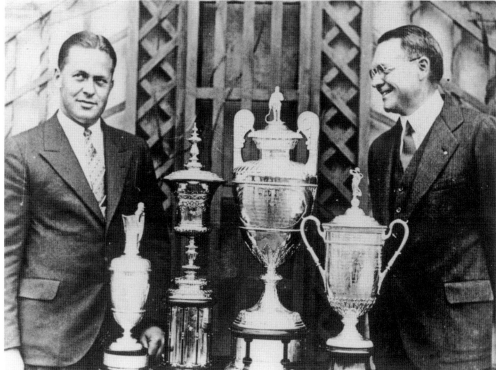

No golfer had ever won such a collection of trophies. A tremendous celebration was held at East Lake in honor of its champion. This was the first time that all four of the trophies would be photographed together. Sharing in the moment with 28-year-old Bobby Jones was his friend sportswriter O.B. Keeler. Keeler had traveled with him throughout his campaign. (Sidney Matthew.)

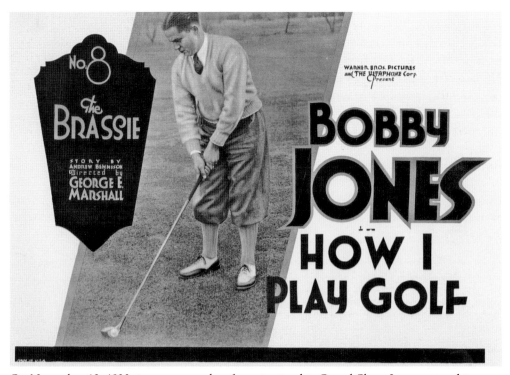

On November 13, 1930, just two months after winning his Grand Slam, Jones entered into an agreement with Warner Brothers Studios to make a series of educational films titled *Bobby Jones: How I Play Golf*. People had often asked Jones how he was able to accomplish what he did, and he felt this would be a great way to bring that knowledge to the masses. The series started with just 12 short episodes, covering topics such as "The Niblick," "The Putter," and "Trouble Shots." The series later expanded to include six more films. The second group went under the title *Bobby Jones: How to Break 90*. Warner Brothers spent an extravagant $1 million producing the films. Jones's techniques are still admired to this day. (Both, Sidney Matthew.)

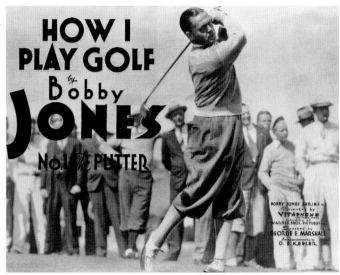

Five days later, on November 18, 1930, Jones also announced his retirement from tournament golf. The husband, father, and lawyer explained that while he loved golf, it was just a game. "First come my wife and children," he said. "Next comes my profession—the law. Finally, and never as a life in itself, comes golf." Pictured from left to right are Jones, Clara, wife Mary, Mary Ellen, and Robert Tyre Jones III. (Sidney Matthew.)

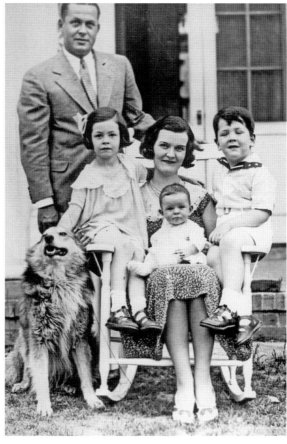

Longtime East Lake manager Scott Hudson praised Jones's decision to retire, saying, "Bobby Jones has done the proper thing at the right time. He has done what no other athlete has ever done. He has made himself the idol and ideal of the young men in golf and business. He has left them a splendid example of sportsmanship." (East Lake Golf Club.)

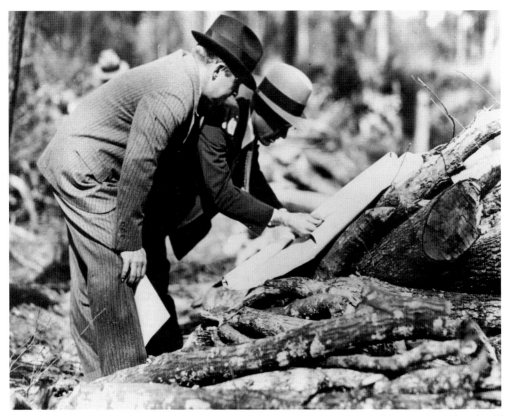

After retirement, Jones sought to build what he felt would be "the world's wonder inland golf course." Working with Clifford Roberts, he purchased the Fruitland Nurseries property in Augusta, Georgia, for the sum of $70,000. The 365-acre plot had originally been an indigo plantation after the Civil War. Golf architect Dr. Alister MacKenzie was contracted to design what became Augusta National Golf Club. Chief engineer Wendell Miller (right) looks over the plans with Jones. (East Lake Golf Club.)

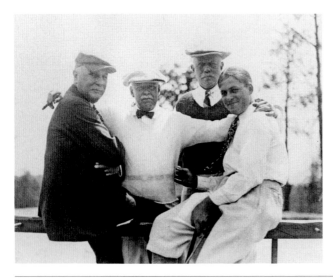

Bobby Jones, his father, and Georgia Power Company founder Harry Atkinson were the only Atlantans who put up money for the new club. Atkinson looked at the younger Jones as an adopted grandson and had supported him throughout his career. Pictured here from left to right are Charles B. MacDonald (USGA cofounder), Harry Atkinson, Ted Blackwell, and Bobby Jones. (Emory MARBL/Sidney Matthew Collection.)

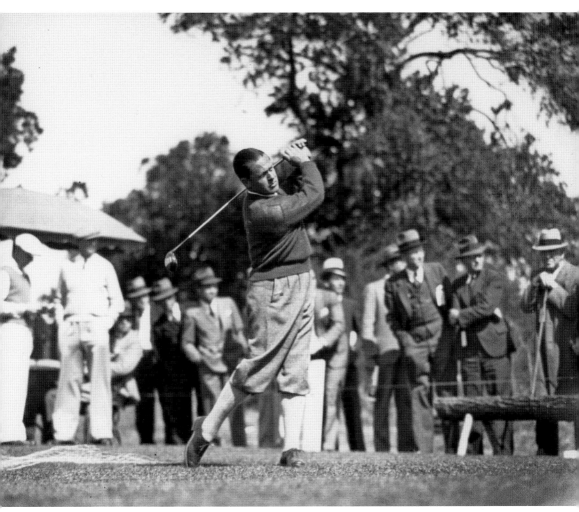

Augusta National opened for play in January 1933. On March 22, 1934, Bobby Jones teed off at 10:35 a.m. to kick off the first Augusta National Invitation Tournament. It was his first competition since his retirement. The idea of the tournament was conceived when the club lost its bid to host the US Open. Spectator tickets for the event cost $2. The field of players included many of Jones's friends and former competitors. Jones finished the tournament tied for 13th place. Horton Smith was the first champion, finishing at a four-under-par 284. He clinched the tourney with a 20-foot birdie putt at the No. 17 (now No. 8). In 1938, the Augusta National Invitation was renamed, becoming the Masters Tournament. (Atlanta Athletic Club.)

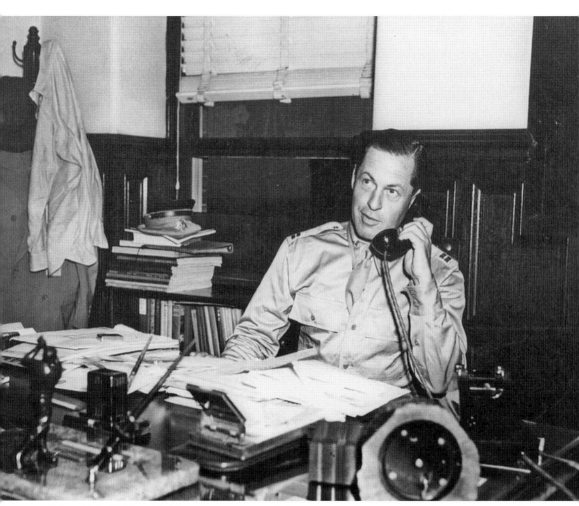

When World War II broke out, Jones joined the US Army Air Forces and served as an officer even though he was already in his 40s. His superiors would have preferred that he stay stateside and play exhibition golf, but Jones had other ideas. He wanted to serve overseas and eventually was stationed in England with the 84th Fighter Wing. Jones trained as an intelligence officer and reached the rank of major in 1943. The 84th was part of the Ninth Air Force and under the command of Gen. Dwight D. Eisenhower. The two men became acquainted, and Jones later helped Eisenhower during his presidential campaign. Following the D-Day landing in Normandy on June 7, 1944, Jones functioned as a prisoner-of-war interrogator with a division working on the front lines. He ultimately was promoted to the rank of lieutenant colonel before leaving the military. (Sidney Matthew.)

Bobby Jones tried to shelter his children from notoriety, encouraging them to enjoy interests other than golf. Robert Jones III, however, was keen on learning to play. His father enlisted Stewart Maiden to give his son a lesson, knowing that Maiden had little patience with someone who showed no potential. While not as talented as his dad, Bob III showed some promise. By age 14, he won the Atlanta Junior Championship in 1941 and even won the 1944 Mid-South Conference title in high school. He also made the golf team at Emory University. Bob III achieved minor success in tournaments and qualified for the US Amateur on three occasions, ending in 1964. He was also the first alternate for the US Open on two separate seasons. (Both, Sidney Matthew.)

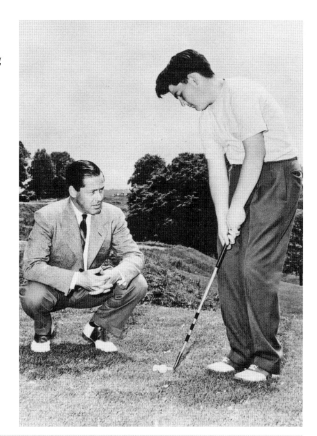

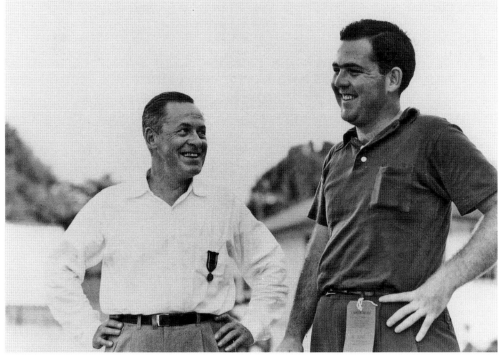

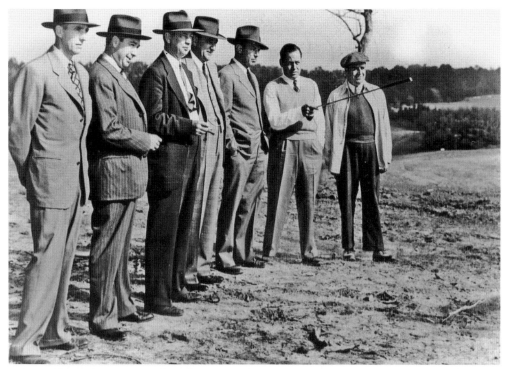

Bobby Jones and Robert Trent Jones teamed up in 1946 to design a new course for Atlanta. Both men were nicknamed Bobby, and the architect declared, "There can only be one Bobby Jones," and thereafter Robert Trent was simply called Trent. The new club opened its first nine holes in October 1947 and was named Peachtree Golf Club a few months later. Pictured from left to right are founders Charlie Black, John Chiles, Doc Irvin, Charles Currie, Dick Garlington, Bob Jones, and Robert Trent Jones. (Sidney Matthew.)

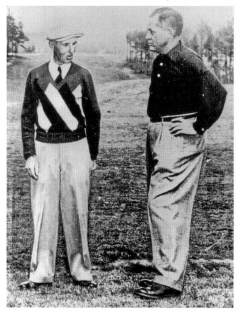

While the course was under construction, Stewart Maiden was brought back to Atlanta to serve as its first pro. The course had yet to have sod put down when Maiden (left) and Jones posed for this image in 1947 on one of the fairways. Maiden's tenure at Peachtree was cut short when he suffered a stroke not long after it opened. Kiltie died on November 4, 1948. (Sidney Matthew.)

BOBBY JONES

While this foursome is all smiles, they had no indication that the scorecard they are looking at was to be Bobby Jones's last. Jones had been feeling tired and having trouble with his coordination but had put off seeing his doctors. On August 15, 1948, he played East Lake with some of his favorite golf companions. Jones had mentioned he was experiencing pain in his back and neck, but he did not seem concerned enough for any of them to give it a second thought. He was hospitalized the next day and underwent surgery on his neck to remove bone spurs. He remained in chronic pain after and never played golf again. From left to right, with their scores that day, are Robert Ingram (79), Tommy Barnes (68), Bobby Jones (72), and club pro Henry Lindner (69). (Sidney Matthew.)

When Alexa Stirling wed Canadian physician W.G. Frazer in 1925, she moved to Ottawa, Canada, and rarely returned to Atlanta. In 1950, the USGA invited her to attend the golden anniversary of the women's US Amateur championship, to be held at East Lake; she accepted. Stirling-Frazer won the women's US Amateur championship title three consecutive times in her golfing career. At East Lake, she was reunited with her old friend Bobby Jones for the first time in 25 years. (Emory MARBL/Sidney Matthew Collection.)

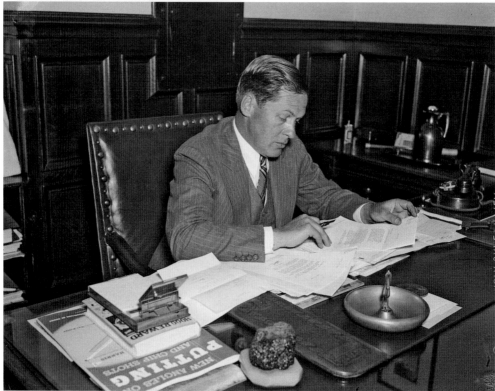

By the mid-1950s, Jones relied on a cane to walk. In 1955, he was diagnosed with a rare central nervous system disease called syringomyelia. The condition occurs when a cyst or fluid-filled cavity forms within the spinal cord. It leads to gradual paralysis and is also quite painful. Jones refused to accept sympathy, saying, "You play the ball where it lies." (Atlanta History Center.)

BOBBY JONES

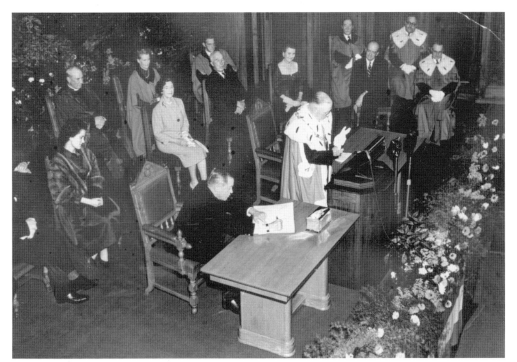

On October 9, 1958, Bobby Jones received what he considered his highest honor. The people of St. Andrews, Scotland, announced they wanted to confer upon "Our Bobby" the title of Freeman of the Royal Burgh of St. Andrews. At first, Jones demurred, not quite understanding its significance. He then learned that this honor was an invitation by St. Andrews to essentially become a citizen of the Burgh of St. Andrews. The only other American to have been bestowed such an honor was Benjamin Franklin almost 200 years earlier. Despite being in tremendous pain, Jones walked to the podium to tell the capacity crowd how important their friendship was to him. In an emotional speech, he said, "I could take out of my life everything except my experiences at St. Andrews, and I would still have had a rich and full life." Above, Jones signs the Burgess Book, making the acceptance official. Below, Jones (left) accepts the award from Provost Robert Leonard. (Both, Emory MARBL/Sidney Matthew Collection.)

Golf Is My Game

Robert Tyre (Bobby) Jones

BOBBY JONES' OWN STORY: A DRAMATIC ACCOUNT OF THE GRAND SLAM YEAR; AND A LOOK AT GOLF THEN AND NOW. ILLUSTRATED.

While Jones wrote five books in all, his 1960 *Golf Is My Game* was among the most popular. His first was the 1927 *Down the Fairway*, written with his biographer, O.B. Keeler. Jones was protective of his name. He declined opportunities to be profiled in magazines or papers if the article was not directly related to an event. Noted Atlanta sportswriter Furman Bisher recounted that he once sought permission from Jones to write a magazine article about his exploits. While he considered Jones a friend, he was flatly denied. Bisher later wrote that Jones told him, "Fuhman [in his native drawl], I'm sorry to disappoint you, but I do my own writing. Nothing bearing my name is published that I don't write myself." (Janice McDonald.)

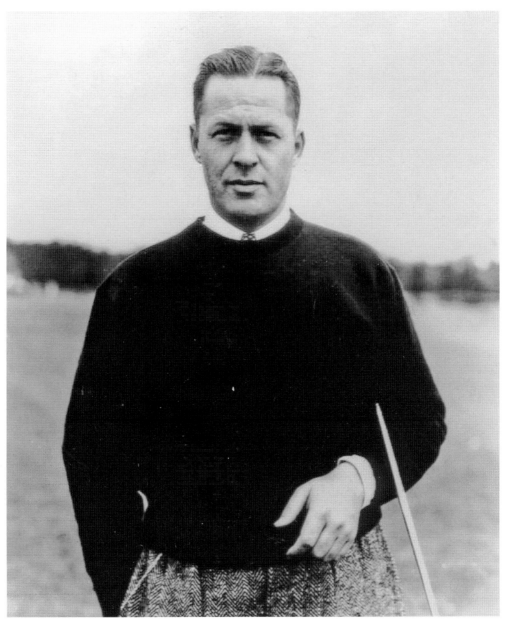

Robert Tyre "Bobby" Jones Jr. passed away in his sleep on December 18, 1971. Word of the loss spread quickly. Across the pond in St. Andrews, play was halted on the course when the news arrived. The flag on the clubhouse in front of No. 18 was lowered to half-staff. Bobby Jones was buried at Atlanta's historic Oakland Cemetery on December 20. Jones's golf abilities are indisputable. His contributions to the game while the sport was still in its infancy are legendary, and so was his commitment to the principles about how the sport should be played. A few years prior to his death, Jones told the *Atlanta Journal-Constitution*, "The quality of sportsmanship is the quality I would most want to be praised for." (Sidney Matthew.)

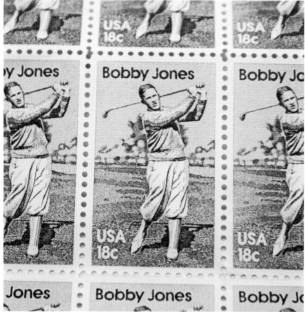

In 1981, the US Postal Service (USPS) paid tribute to Bobby Jones with an 18¢ stamp, which featured him wearing period golf plus fours from the 1930s. It was unveiled in November 1980 to mark the 50th anniversary of his Grand Slam. In doing so, the USPS broke its own rules of waiting 10 years after a person's death before issuing stamps for anyone but a president. Jones received his honor three months prior to what would have been the 10th anniversary of his passing. (Janice McDonald.)

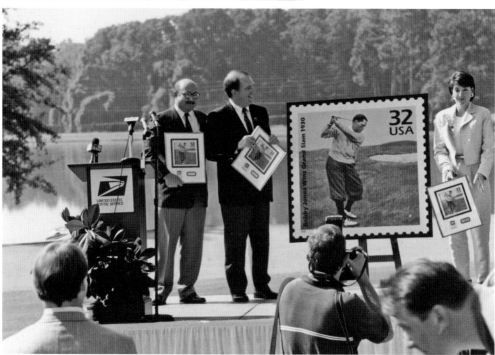

The USPS chose to honor Bobby Jones a second time in 1998. The champion golfer was included as part of 15 commemorative stamps in the "Celebrate the Century" series. The souvenir sheet featured 1930s subjects in such categories as people and events, arts and entertainment, lifestyles, sports, and science and technology. Jones biographer Sidney Matthew (left) takes part in the stamp unveiling at East Lake with Jones's grandson Robert T. Jones IV and granddaughter Anne Hood Laird. (East Lake Golf Club.)

THE IN-BETWEEN YEARS

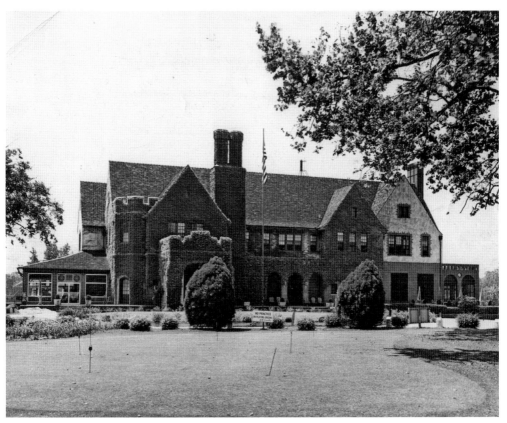

Led by Paul Grigsby, a group of Atlanta Athletic Club members formed East Lake Properties to save the course where so many people felt golf had its greatest legacy. They successfully raised the $1.8-million asking price to purchase the East Lake Club and its course. On April 9, 1968, the Atlanta Athletic Club at East Lake became East Lake Country Club. (East Lake Golf Club.)

In 1970, a public housing project called East Lake Meadows was constructed on the site of the old No. 2 course. Poverty, drugs, and crime began to permeate the neighborhood. Local police referred to it as "Little Vietnam." It was estimated that only 13 percent of the 1,400 residents of the project had a job. Nine out of 10 residents admitted to having been victims of crime. At one point, East Lake Meadows was averaging a murder a week, a statistic that was 18 times higher than the national average. The crime wave was not confined to the Meadows project and spilled into the surrounding areas. Residents were selling their homes and fleeing the neighborhood. (East Lake Golf Club.)

THE IN-BETWEEN YEARS

In the 1970s, the membership of 300 dropped to about 50. The course stayed virtually empty, and the use of the facilities was light. Paul Grigsby sold his business and devoted himself full-time to the club. For the first several years, there was no official manager except Marion Peck, who oversaw the facilities and course operations. (East Lake Golf Club.)

The deteriorating neighborhood forced the country club to put a black tarp around the chain-link fence to help shield the course and facilities from outside goings on. It was not unusual for golfers to hear gunfire, and on more than one occasion, players were actually robbed while on the course. (East Lake Golf Club.)

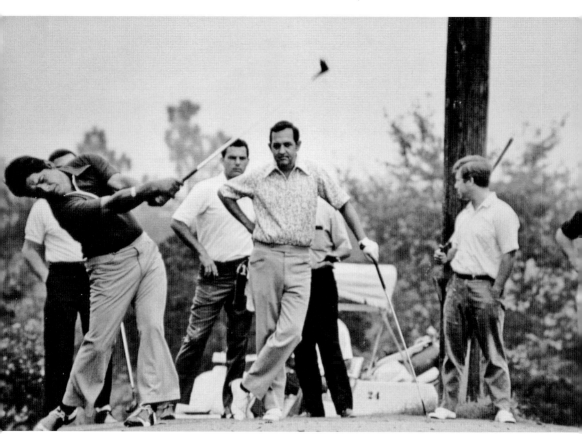

Despite the decline of the club and its surroundings, East Lake was still beloved because of its legacy. Among the core group who kept their membership was John Imlay. Imlay is at the center of this image, leaning on his club watching Lee Trevino hit during the 1971 US Open at Merion. Imlay says he applauded the shot and Trevino joked, "What do you expect from the US Open champion? Ground balls?" Trevino beat Jack Nicklaus for the US Open that year in a playoff. Imlay was among those who supported Tom Cousins to save East Lake. Having known Bobby Jones personally, in 2014 Imlay and his wife Mary Ellen launched a nonprofit organization called The Friends of Bobby Jones. The organization is dedicated to promoting the standards, values, and sportsmanship of Jones. (John Imlay.)

THE IN-BETWEEN YEARS

Tommy Barnes was another person who continued to be faithful to the course that he was associated with. In 1988, at the age of 73, Barnes shot a 62 while playing golf at East Lake, which set a new course record that had been held since 1916. The previous record of 63 had been held by Bobby Jones and Stewart Maiden, who guided the legendary Jones. (Sidney Matthew.)

For years after Jones quit playing, his double locker remained in the downstairs members' locker room. It had been presented to him by the membership after the 1930 Grand Slam. It never bore his name, just the numbers 690 and 691. At the time this photograph was taken in 1991, the locker had become a fixture in the pro shop. Pictured from left to right are Jones's club maker Woodrow Bryant, Tommy Barnes, and Sidney Matthew. (Sidney Matthew.)

New leadership took the helm of East Lake in the 1980s, working to repair the course and some of the facilities. The club executive committee set up promotions, including special activities and social activities to help increase membership. The efforts worked to an extent, but membership dues were so low the club continued to lose money. (East Lake Golf Club.)

In the early 1990s, East Lake was showing its age. The crime rate in the community prevented many from even driving into the neighborhood. Membership was at an all-time low, and the club was on the brink of bankruptcy. Previous member Tom Cousins stepped in, purchased the club, and promised to restore it to its former splendor. (East Lake Golf Club.)

GOLF WITH A PURPOSE

In November 1993, Atlanta businessman and former East Lake member Tom Cousins purchased the club for $3 million. He then turned it over to his charitable organization, the CF Foundation, run by his daughter, Lillian Giornelli. Cousins pledged not only to restore East Lake in tribute to the great players who had shaped it but also to use golf as a catalyst to rebuild the surrounding community. As Cousins put it, "Golf with a purpose." (Sidney Matthew.)

Many thought the Cousins plan was based on idealized memories, but Cousins had an evolving vision of what East Lake and its neighborhood could become. He created the East Lake Community Foundation (now East Lake Foundation) to operate and maintain the project. The resulting public/private partnership infused $120 million into the community. Almost a quarter of the money came from Cousins himself. The refined vision was dubbed a "Purpose Built Community." (East Lake Golf Club.)

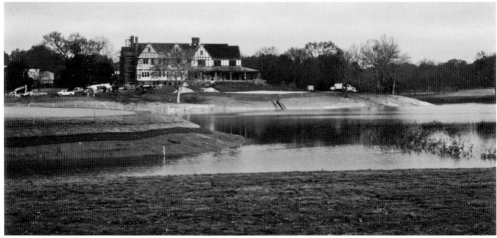

The strategy was very detailed, but the rebuilding contained three distinct phases that were all tied together. One Cousins mandate was that East Lake's golf course be taken back to its original 1913 Donald Ross design. Golf architect Rees Jones was brought in the rebuild the course, making East Lake an eclectic Bendelow-Ross-Cobb-Jones hybrid. The club itself was shut down while the transformation took place. (East Lake Golf Club.)

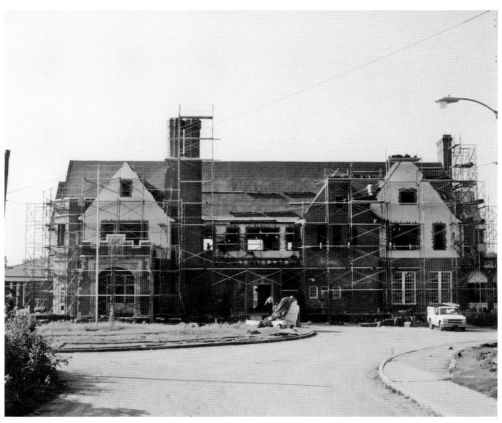

The East Lake clubhouse, which had once been considered a showplace, had also become a remnant of its former glory. Cousins chose to renovate it from top to bottom. Working from the plans by famed architect Neel Reid and his partner Hal Hentz, an army of workmen and artisans descended on the old Tudor structure. (East Lake Golf Club.)

While the clubhouse was a Reid design, the interior was designed by another architect in Reid's firm, Phillip Shutze. Reid had died of a brain tumor while the original work was under way, and Shutze stepped in to finish the interior. The restored building was adorned with Bobby Jones memorabilia from Sid Matthew's collection and mementoes paying homage to other East Lake champions, including Charlie Yates, Tommy Barnes, and Charlie Harrison. (East Lake Golf Club.)

THE EAST LAKE GOLF CLUB

The new focus depended on rebuilding the neighborhood itself. In 1995, Cousins entered into a partnership with the City of Atlanta to raze the East Lake Meadows housing project and build an entirely new mixed-income development. The 170-acre subdivision was called The Villages of East Lake. It consists of 542 townhomes, apartments, and duplexes. Half of the homes are occupied by low-income families. Atlanta's first charter school was planned for East Lake. Cousins told the *New York Times*, "We need to do something about situations like this all over the country, or we're going to lose our future. If I had grown up the way a lot of kids had to grow up in East Lake, I would have gone bad a lot sooner than most of them did." (East Lake Golf Club.)

Cousins not only put up his money but also personally pitched in on more than one occasion to help in community projects. The residents of East Lake Meadows had been skeptical of the outside businessman telling them he was going to change their community. They soon saw his commitment. The model for his "Purpose Built Community" of East Lake became one that other communities in the United States have also adopted. (East Lake Golf Club.)

Redoing the course was not just a matter of resodding and reseeding. The first order of business was to reconstruct all of the drainage. This undertaking also meant that East Lake itself was drained and dredged. Bridges and cart paths were also rebuilt. By the time the course reopened in 1996, it was in pristine condition. (East Lake Golf Club.)

THE EAST LAKE GOLF CLUB

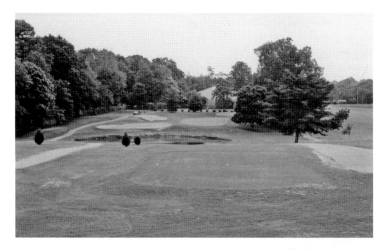

These three photographs show the contrast of changes made as the course was being rebuilt. These particular images concentrate on hole No. 2. At above left, the hole from the tee box is seen just before construction began. Notice the patchy grass and how flat the terrain appears. The fairway has been excavated, and huge drainage pipes have been installed underneath to accommodate the water needed for the pond. The pond was completely emptied, as seen in the upper right. At center left, the green has been reconstructed, but the sand bunkers are still empty. At below left, the newly sodded fairway and sand traps are in place just before the pond was to be refilled. (All, East Lake Golf Club.)

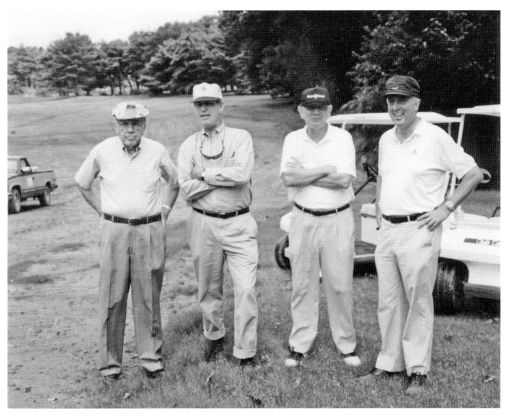

Rebuilding the course was a project watched closely by many who had spent their youth at East Lake as Tom Cousins had. Joining Cousins on this outing to check out the course reconstruction are, from left to right, Charlie Yates, Charles Harrison, Tommy Barnes, and the golf architect behind it all, Rees Jones. (East Lake Golf Club.)

When the course was ready for play again, there was cause for celebration. The clubhouse itself still needed work, but a group of new members and old friends gathered for an invitation-only match. It was a full field of Tom Cousins's friends. As was fitting, the first person to tee off was the man who had envisioned it all: Tom Cousins. (East Lake Golf Club.)

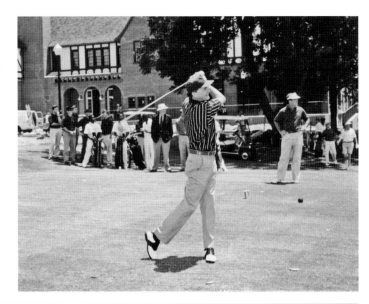

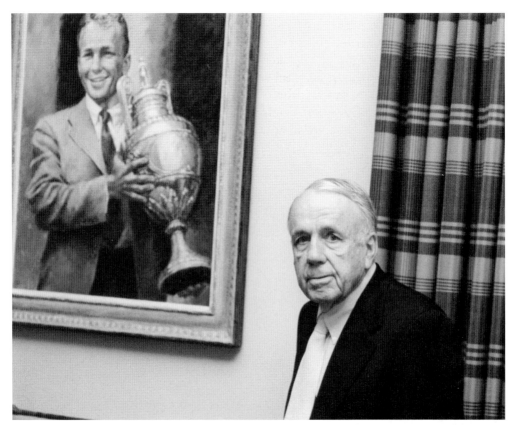

East Lake's longest-surviving champion was honored in 1998 with the christening of the Charlie Yates Golf Course. The 18-hole public course was designed by Rees Jones and built on some of the ground where the old No. 2 course was originally located. Charlie Yates, at age 83, was the guest of honor at the opening, which included a ceremonial first drive by superstar golfer Tiger Woods. The course was designed to be easy enough for a beginner but challenging enough for a seasoned player. Festivities included a tour of the new The Villages of East Lake housing development, which includes both townhomes and garden apartments for mixed-income residents. Above, Yates poses with a portrait of himself as the 1938 British Amateur champion, and below is program from the opening ceremony. (Both, Sidney Matthew.)

GOLF WITH A PURPOSE

The Charlie Yates Course also became home to East Lake Junior Golf Academy (ELJGA), an after-school program designed to help tutor students with their lessons and engage them in educational enrichment programs. It also taught them etiquette of the game of golf and its principles of discipline, hard work, and integrity. Students received priority in playing the Yates course. (East Lake Golf Club.)

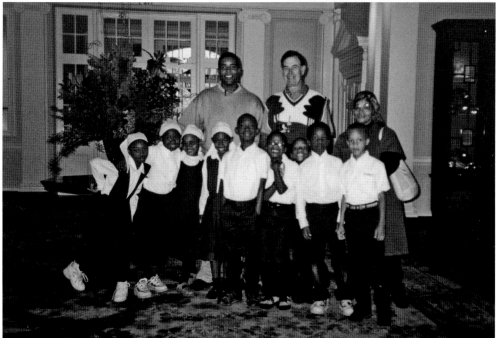

The academy was open to children from kindergarten through eighth grade and was later expanded. ELJGA director Leon Gilmore is shown here (back left) with champion golfer and East Lake member Charlie Harrison (back right) and one of the Academy's first group of students. The East Lake Foundation also implemented a caddy scholarship program to help send kids to college. (East Lake Golf Club.)

THE EAST LAKE GOLF CLUB

Once the rebuilding of East Lake was complete, people were anxious to return to the course where Bobby Jones had learned to play. The first official tournament on the new course was the 80th-annual Western Junior Amateur in 1997. Nick Cassini, an 18-year-old Atlanta native, won the tournament, defeating Bryce Molder of Conway, Arkansas, 2 and 1. Cassini is pictured here (left) with Western Golf Association's Bob McMasters. (East Lake Golf Club.)

The PGA Tour added East Lake to its rotation for the 1998 Tour Championship. Since 2007, East Lake has exclusively hosted the FedEX Cup and Tour Championship by Coca-Cola as the final official event for the PGA Tour, bringing together the top 30 money leaders for the year. The tournament determines such top honors as player of the year, leading money winner, and the year's lowest scorer. That first year, Vijay Singh posted a then-record score of 63 during the tournament. (Emory MARBL/Sidney Matthew Collection.)

GOLF WITH A PURPOSE

A month after the Tour Championship, pro golfer Jack Nicklaus held a golf clinic for members of East Lake. Known as "the Golden Bear," Nicklaus won 18 major championships in his career and collected 19 second-place and nine third-place finishes. In 1975, the USGA awarded him the highest honor, the Bobby Jones Award, given in recognition of distinguished sportsmanship in golf. (East Lake Golf Club.)

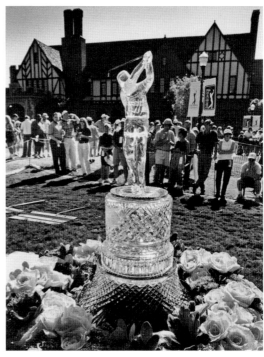

Ending the PGA Tour season at East Lake was a popular move given the club's rich history and the foundation's commitment to keep the course in tournament-worthy shape. The Tour Championship returned two years later in 2000 and again in 2002 and 2004, alternating between Atlanta and Houston's Champion's Golf Club. To mark East Lake's centennial, PGA Tour commissioner Tim Finchem declared East Lake the permanent home to the Tour Championship. (East Lake Golf Club.)

THE EAST LAKE GOLF CLUB

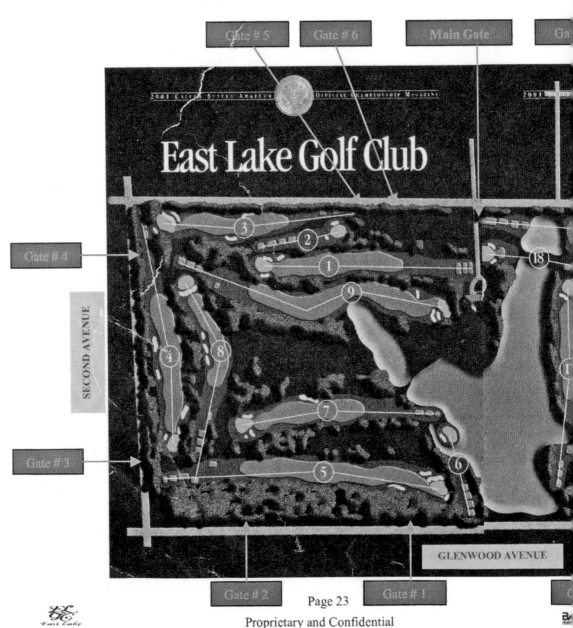

Gate # 5

Gate # 6

Main Gate

Ga

Gate # 4

Gate # 3

SECOND AVENUE

East Lake Golf Club

GLENWOOD AVENUE

Gate # 2

Gate # 1

Page 23

Proprietary and Confidential

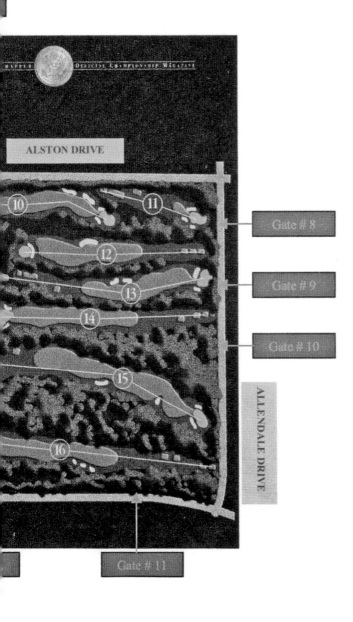

ALSTON DRIVE

10 11

Gate # 8

12

Gate # 9

13

14

Gate # 10

15

ALLENDALE DRIVE

16

Gate # 11

This aerial view shows the layout of East Lake's present course, which measures 7,374 yards from the championship tees and plays to par 72. No. 6, known as the island hole, is considered the course's signature hole. At 168 yards, it is a par-3. It existed on the original Tom Bendelow course but was the par-5 No. 16. It is the oldest island green in the United States. The current course record is 60 and was set on September 15, 2007, by Zach Johnson during the Tour Championship presented by Coca Cola. East Lake's Donald Ross/Tom Bendelow/ George Cobb course design, restored by Rees Jones, provides an opportunity for its members and their guests to retrace Bobby Jones's footsteps on a world-class layout. (East Lake Golf Club.)

THE EAST LAKE GOLF CLUB 125

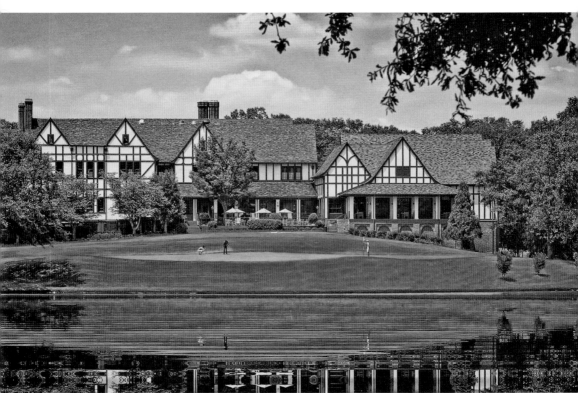

Prior to the 2008 Tour Championship, East Lake's course and its clubhouse both underwent major renovations. Holes No. 7, No. 15, No. 16, and No.17 all received face-lifts. No. 17 underwent the most significant change by shaping the fairway closer to the lake's edge, adding a third bunker, and moving the green closer to lake. The clubhouse received a 20,000-square-foot addition. Using Neel Reid's historic guidelines, plans were drawn to feature a half-timber facade and clay tile roofing. To match the roof of the existing building, a company from Ohio was brought in to re-create the tiles. The roof alone has 13,000 square feet and required 34,000 new tiles. The interior included a new ballroom, an expanded grill and kitchen, and new administrative rooms. The course closed down in March and was finished in time for the tournament in September. (Duane Stork Photography.)

GOLF WITH A PURPOSE

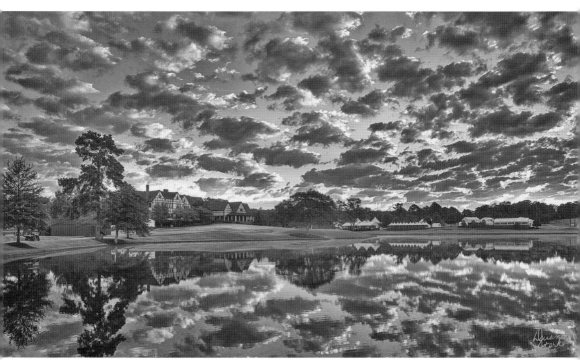

The East Lake Golf Club of today is more than a golf course, it is a tribute to its past and a beacon toward the future. Early members like Bobby Jones, Alexa Stirling, Charlie Yates, Watts Gunn, and Charlie Harrison influenced the evolution of golf itself. They were world ambassadors for their home club. Those who know golf know of East Lake. East Lake's social legacy is also one of a nationwide impact. The East Lake Foundation brought not only the course but also the surrounding neighborhood back from the brink of destruction. It created hope where there once was despair, and it is now a model for other cities. East Lake is a testament to its rich history and a symbol of hope for what is still to come. What began as a vision simply of "Golf with a Purpose" has evolved into a "Purpose Built Community" that transcends golf. (Duane Stork Photography.)

DISCOVER THOUSANDS OF LOCAL HISTORY BOOKS FEATURING MILLIONS OF VINTAGE IMAGES

Arcadia Publishing, the leading local history publisher in the United States, is committed to making history accessible and meaningful through publishing books that celebrate and preserve the heritage of America's people and places.

Find more books like this at
www.arcadiapublishing.com

Search for your hometown history, your old stomping grounds, and even your favorite sports team.